JEFF SMITH'S

POSING TECHNIQUES
for Location Portrait Photography

AMHERST MEDIA, INC. ■ BUFFALO, NY

Copyright © 2008 by Jeff Smith.
All rights reserved.

Published by:
Amherst Media, Inc.
P.O. Box 586
Buffalo, N.Y. 14226
Fax: 716-874-4508
www.AmherstMedia.com

Publisher: Craig Alesse
Senior Editor/Production Manager: Michelle Perkins
Assistant Editor: Barbara A. Lynch-Johnt
Editorial Assistance: Carey A. Maines and John Loder

ISBN-13: 978-1-58428-225-9
Library of Congress Control Number: 2007926866
Printed in Korea.
10 9 8 7 6 5 4 3 2 1

Table of Contents

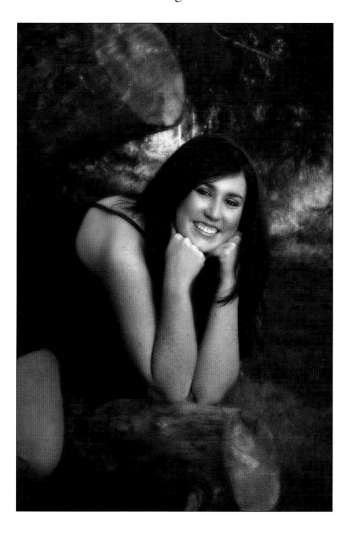

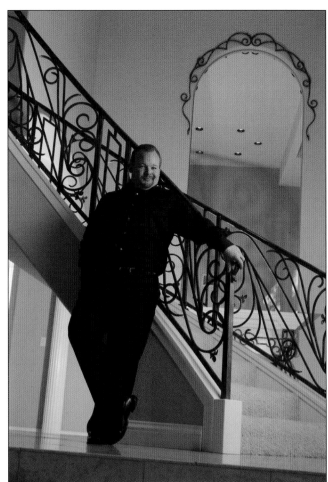

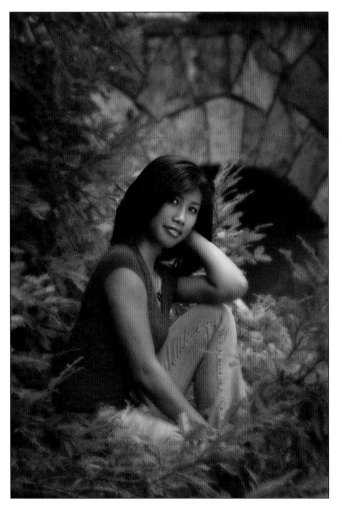

Introduction

The human form can be shaped and proportioned to be one of the most beautiful subjects on earth. Conversely, it can be arranged in a such way that it makes even the most attractive person look disfigured. Further complicating this arrangement of the human form are all the different shapes and sizes of people that we, as professional photographers, must work with. It is one thing to make a perfect model look good during a test session or seminar—but use the same poses on a good portion of our average customer base, and you will end up with an unsalable portrait.

So, what is it that makes one arrangement of body parts look so graceful, while another arrangement looks so awkward? I believe there are two parts to posing: the basic mechanics of posing each part of a person's body in a flattering way, and the creative vision to see how this arrangement establishes the basic look or style of the portrait. Both of these subjects will be explored in this book.

Specifically, we will be exploring techniques for location portraits. As you might guess (or have learned from experience), posing on location requires a different approach than posing in the studio. In the studio you have chairs, couches, props, and posing aids. Outdoors, you typically have to work with

Flattering poses arise from a solid understanding of the human body as well as from the creative vision to make the right choices for the setting.

Posing on location requires an different approach than posing in the studio.

Although working on location can be challenging, it produces some of my most creative portraits.

what the scene has given you. Even at indoor locations, you will not have the total flexibility that you would in your studio. In both situations, you have to use your imagination and sometimes hunt for posing aids that will allow the subject to pose in the way you envision.

Although working on location can be challenging, I find that it produces some of my most creative portraits. This is because it allows me to tailor a portrait specifically to my client's needs, by selecting a location that has meaning to them or reflects their style and vision for their portrait.

As the title implies, this book is on posing. I will talk briefly about other aspects of portraiture on location, but only as they apply to posing. For a more in-depth study of all the other aspects of location photography, please refer to two of my other books: *Outdoor and Location Portrait Photography* and *Jeff Smith's Lighting Techniques for Outdoor & Location Portrait Photography*, both from Amherst Media.

1. The Goals of Posing

Other than lighting and expression, nothing is more important to a professional portrait than posing. Careful, thoughtful posing makes your client look beautiful and completes the overall look of the image in a way that is consistent with its intended use. Furthermore, posing is critical to producing portraits that your clients will actually want to own. This makes your job as photographer more rewarding—both personally and financially.

SUIT THE PURPOSE OF THE IMAGE

There are many reasons why a portrait might be taken. Unfortunately, many photographers approach the posing of a client in the exact same way, no matter what the purpose of the image. For example, the pose you'd use for a young woman who wanted a portrait to give to her father would be quite different than you'd use if you knew she planned to give the image to her boyfriend. It would also be different than the kind of pose you'd want to use if she needed a portrait to promote her new real estate business. (And, for that matter, if the client's new business was a daycare center, you'd probably use a different pose for her business portrait than if she were opening a new law practice). We'll look at this issue when discussing the purpose of the portrait in chapter 2.

Mom and Dad will love a portrait like this, but it wouldn't be a good choice if the subject needed to present a professional appearance.

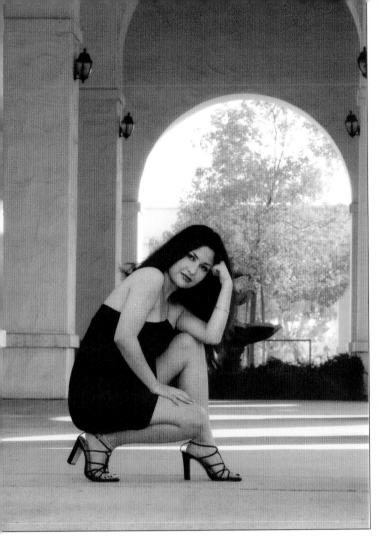

LEFT—In an architectural setting, more formal attire can support a glamorous posing style. RIGHT—A casual outfit in an outdoor setting calls for a casual pose.

ENHANCE THE STYLE OF THE IMAGE

Selecting the right clothing and setting goes hand in hand with posing; it is only when the right pose is combined with the proper clothing, in the proper setting, and with the appropriate expression, that the portrait attains a sense of style. Only when everything in a portrait makes sense visually do you achieve a portrait that really works. Achieving this requires that you look at every aspect of the portrait and match each element to the others.

FLATTER THE SUBJECT

A client I photographed years ago led me to write my book *Corrective Lighting, Posing, and Retouching Techniques for Portrait Photographers* (also from Amherst Media). She was the person who taught me what my job as professional photographer *really* was.

This young lady was very overweight . . . and none of the classes I ever had taken, or the books I had read, had prepared me for photographing a person like this. She wasn't the first overweight person I photographed, of course, but for the first time I really thought about how this young lady would feel looking at her images. So I went into her session and I start hiding every area where weight gain was visible. I used flowers, fake trees, columns, arms, legs,

and hair to cover the areas I knew she wouldn't want to see. When I was done I was exhausted.

This was in the days of film, so two weeks later the young lady and her mother came in to see the portraits. I happened to be there, so I stood by while they looked at all the images. As the mother looked at the proofs she started to cry. She walked up to me, hugged me, and said, "I always tell my daughter that she is a beautiful woman, and these portraits show the beautiful woman that I see."

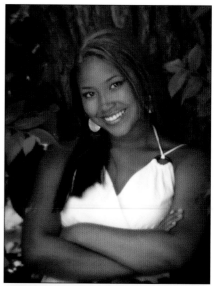

At that moment, I realized what I try to teach in all my books: it is not about *us*, it is about *them*. This is challenging. In the United States, the population is heavier (and more self-conscious about it) than ever before. Additionally, the standard of beauty that we see in the media keeps going up, getting farther and farther away from the average client. As a result, many

People deserve to look great in their images. Your job as a professional photographer is to make this happen for them.

Want to maximize the sales from each session? It's simple: make sure your subject looks great at each session.

people experience a great deal of frustration about their personal appearance—and we are in *the appearance business*.

YIELD MORE MARKETABLE IMAGES

When people feel there is no hope that they can look good in a portrait, they will quit having their portraits taken. That is bad news for portrait photographers—and it underscores the fact that we must devote ourselves to making all of our clients look great if we hope to sustain our businesses in the long term.

Of course, making this our objective isn't *just* about the long term: it's about profiting enough from every session that we can pay the mortgage, keep the electric on, and feed our family. (And that's at the very least; hopefully you will set your financial goals much higher!)

To make money, you must sell the work you create. That may seem obvious, but I believe there are lots of photographers who can take beautiful pictures of beautiful people, yet very few who can make the average client look beautiful enough to make a good living in this profession. If you want to be an art photographer and do only what looks good to *you*, you have two choices: become a photography instructor or make photography your hobby rather than your profession. If you want to make your living as a professional

photographer, you will have to learn to listen to your clients and give them what they want.

Like most photographers, I learned the classic rules of posing; then, I learned that they didn't sell because clients didn't like them. As a result, I had two choices: I could make my clients study classic posing (so they would understand how smart I was), or I could learn to create poses that my clients liked. I chose to satisfy my clients, and the rewards have been greater than I ever thought possible. When you are told that you are as good as you think you are—and are told it by people who are spending large sums of money on your work—you are truly in a satisfying profession!

So keep this in mind: salable posing is much different than artistic posing. The greatest hurdle photographers must make is getting over the "photographer knows best" way of thinking. Most photographers like to think of themselves as artists, free spirits who get to create little works of art—but someone else has to live with that "art." In the end, the client and their money will determine if your image is art or not. For example, it you show a larger woman of today a portrait of a full-figured woman that was painted by one the old masters and she will say that it is art. Take a portrait of that same woman of today in the exact same pose, and she will say she looks like the Pillsbury Dough Boy. Again: art is in the eye of the buyer, not the creator.

Salable posing is different than artistic posing—it's posing based on what your clients actually like.

Once you've mastered the technical aspects of creating a good portrait, you can begin to address the creative aspects and fine-tune your images so that every aspect makes sense visually.

There comes a time in the career of every photographer when they get past asking *how* and start asking *why*. As a beginning photographer, you are consumed with the *how*—so you read books, go to seminars, and emulate the methods of your teachers. This somewhat satisfies the longing to understand the *how* of what you are studying. At some point, though, the *how* gets easier; that's when you you start to ask yourself *why*. Why did the photographer choose that pose? That lighting? That background and fore-

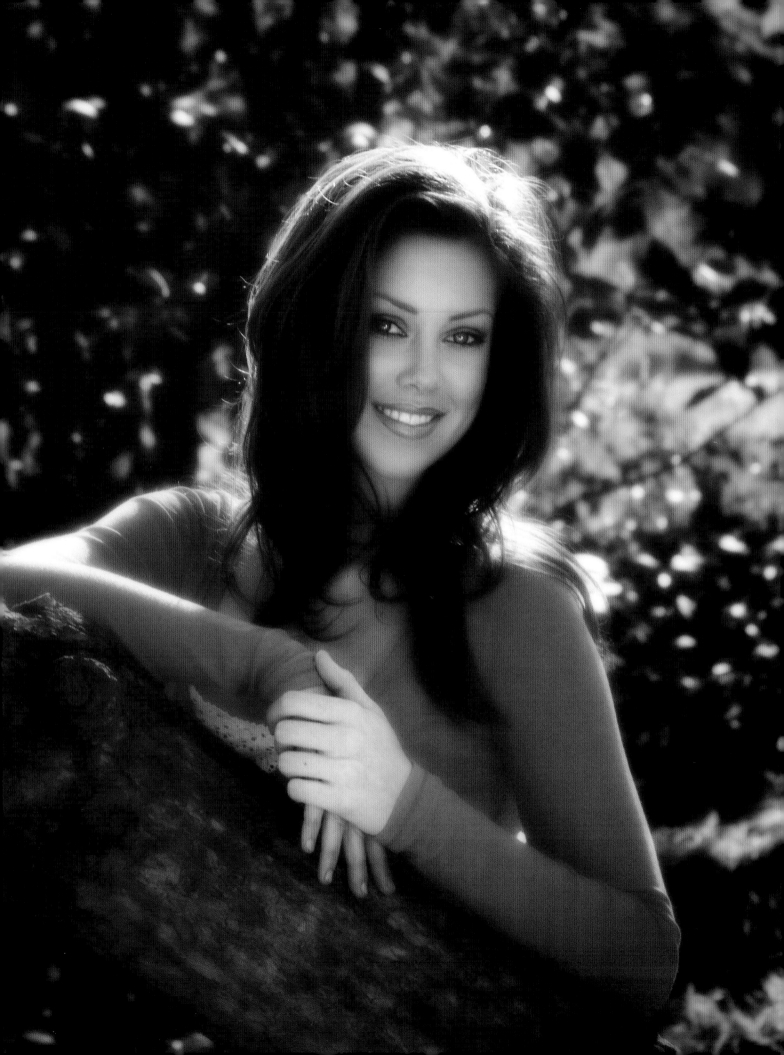

ground? Once you starts to ask these questions, your talent is ready to grow exponentially, because you are moving toward being able to design a portrait that has a sense of style.

Unfortunately, some photographers never get to the *why*. They spend their lives looking for the *how*—and then wonder why their work never seems to look as good as that of some photographer they admire. The truth is, if I showed you a thousand poses and you sat down and memorized each one, you still would never create the same images that I have. You might know the pose, but you wouldn't know why I selected it. This is like giving you a gun without showing you how to aim it.

Asking *why* is the first step to taking portraits with a sense of style. Yet, many photographers step into their camera room and know little to nothing about who they are photographing, the clothing they have brought in, or the reason the portrait is being taken. Without this information, they cannot make the decisions that are critical to creating professional-quality portraits. None of what appears in your portraits should be an accident; if something is in your frame it should be there because you put it there (and because you know why you put it there). When you make conscious choices about every element, there are no eyesores to distract from the client's face. Everything in the portrait coordinates seamlessly with everything else, and the portrait will be as beautiful in ten years as it is today.

DETERMINE THE INTENDED USE OF THE PORTRAIT

The first question for clients, the question that starts the whole process, is the intended use of the portrait or the reason it is being taken. Every other de-cision is based on their answers to that first question. After all, how can you select the right clothing, choose the style of lighting, and direct them into a pose if you don't know the reason the portrait is being taken?

How can you select the right clothing if you don't know the reason the portrait is being taken?

As I mentioned in the previous chapter, you need to get some specific de-tails. For example, a portrait of a woman for her husband might be a little dif-ferent for Joan, whose husband is a minister, than for Ruth whose husband is a mechanic with pinup girls hanging all over his shop. Right there, those descriptions probably brought some ideas to mind—but you must never as-sume. Remember, this is not about what *you* think, it's about what your *client* wants. The preacher's wife may want a alluring private portrait for her hus-band; the mechanic may look at his wife much differently than the pinup girls in his shop. You will only know this by talking with each client to see what it is they want.

Many times, this process is complicated by the need to please two buyers. This is always the case, for example, with a senior portrait. Seniors and their parent rarely want the same style of portraits. Multiple buyers exist in other photography situations, too. There are often differences in taste between a

bride, her mother, and her mother-in-law (create one photo that satisfies *those* three woman, and I will say you are a genius!). Many children's portraits now involve two sets of parents who need to be happy with the session. Even in a family portrait, chances are good that not everyone in the group will have the same tastes. If you exclude any of these multiple buyers, the simple fact is that you won't make as much from the session as you could.

Once you have determined the client's (or clients') purpose for taking the portrait, you can begin to start coordinating all the parts of the image with that end in mind. Stephen Covey, author of *The Seven Habits of Highly Effective People* (Free Press, 1989) suggests that you "begin everything with

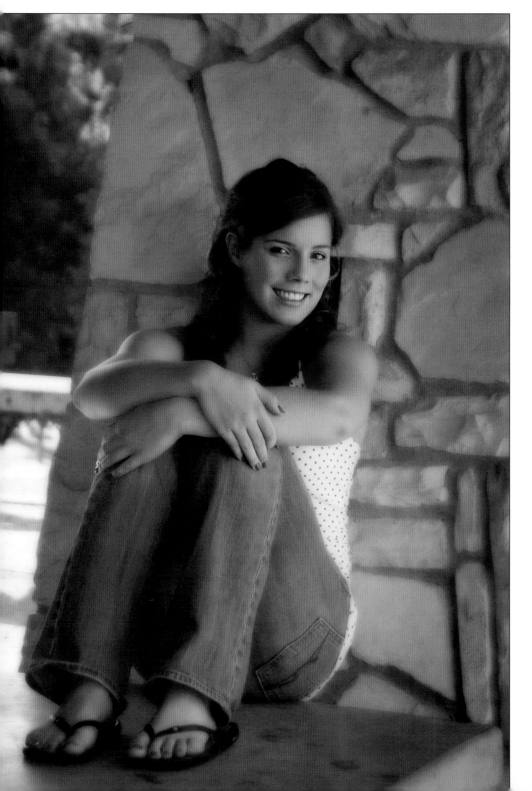

Here, the subject's casual clothing was paired with a casual setting and a casual pose for an image that is well coordinated and makes sense visually.

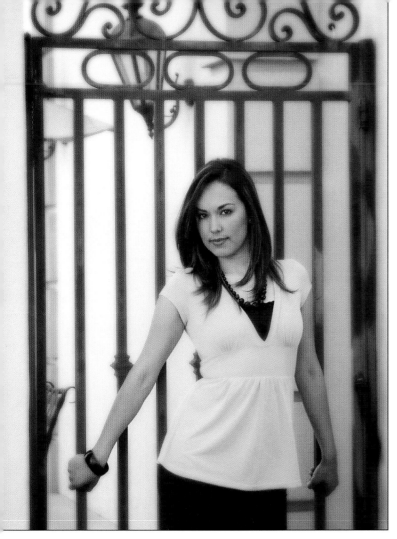

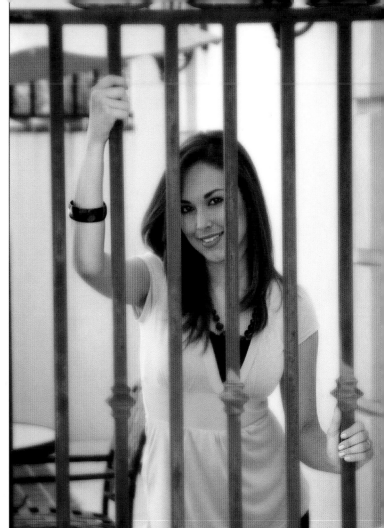

Clothing that is a bit dressier is well suited to an architectural setting.

the end in mind." If you do that, you will almost always reach your intended destination. When you begin with the final portrait in mind, you can tailor each decision to produce the result you envision.

CHOOSE THE CLOTHING

The next step is to help the client select clothing that works with that end result in mind. Most photographers, no matter how fashion-impaired they are, can tell the difference between casual clothing, business clothing, and elegant clothing. You can select the clothing to match the type of posing you want to use, or you can match the posing to the client's choice of clothing.

Whatever you select, the clothing and pose need to be appropriately paired. Therefore, if your subject wants be be barefoot in shorts and a summery top, you'll need to use a casual setting and a casual pose. Conversely, you might have planned a shoot to include majestic architecture in the background; in this case, your subject should be attired in something more formal, like a dress or a suit. (*Note:* Of course, you can also decide to use a combination that isn't the obvious choice, like an evening gown in the desert, but you still need to make sure that everything in the portrait comes together to visually make sense.)

I should note that getting clients to bring in the types of clothing that are generally best for portraiture (classic styles, dark colors, long sleeves, etc.) is always a challenge. My view of clothing is the opposite of my clients' views. They buy or bring in clothing they like and want to see in the portrait; I look for ways to hide the clothing and the problems that it makes visible. I want the viewer's focus to be on the face. Everything else is secondary, even in a

Scenes with linear backgrounds are traditionally regarded as having a masculine feel, but today those "rules" just don't apply. If you want to use train tracks as your background, you should not work on operational tracks. Safety must always come first.

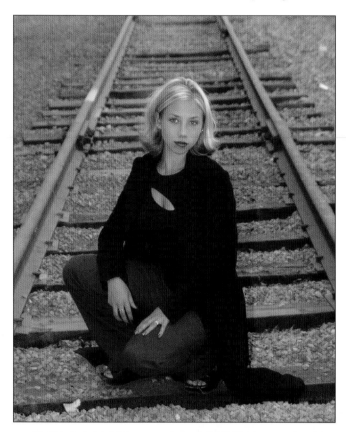

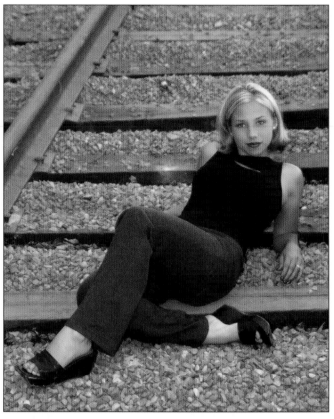

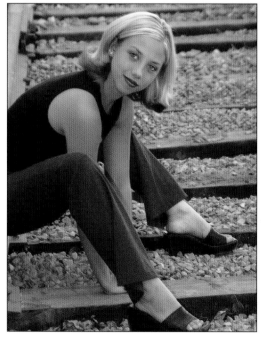

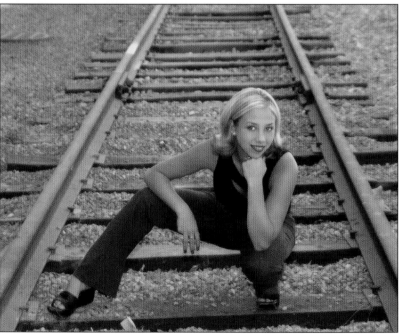

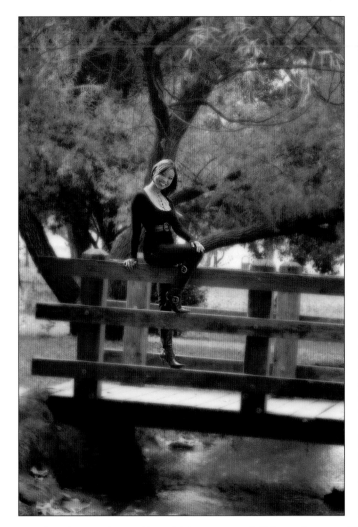

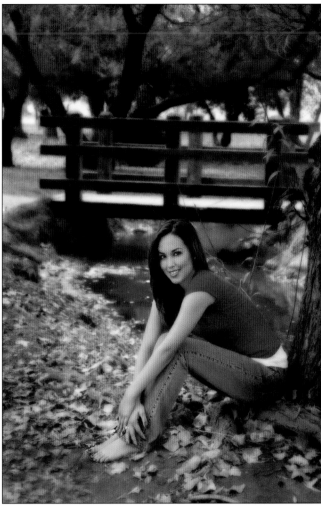

Some locations can be used in multiple ways, so keep your mind open to the possibilities.

full-length pose. (*Note:* The exception is in boudoir and glamour photography, where the emphasis may be more on the person's physical attributes than on their face.) Some tips for getting better compliance from your subjects on this issue are covered in chapter 9.

CHOOSE THE SETTING

The predominant lines and textures in a scene are what determine its overall feeling, so be sure to evaluate these carefully. Studying art theory will help you determine what feeling these lines and textures communicate. As you begin looking for the feeling that each setting conveys, you will start to pick up on the ways the various lines and textures alter the feeling of the background.

A scene that has strong linear lines (like a row of columns on a porch or portico) communicates a sense of structure and strength; scenes that have curved lines (like the draping branches of a tree) provide a softer, more painterly look. Because of their traditional associations, linear backgrounds are often considered more masculine, while ones with curved lines tend to be considered more feminine. This does not, however, mean that you should only use "feminine" backgrounds when creating portraits of female subjects.

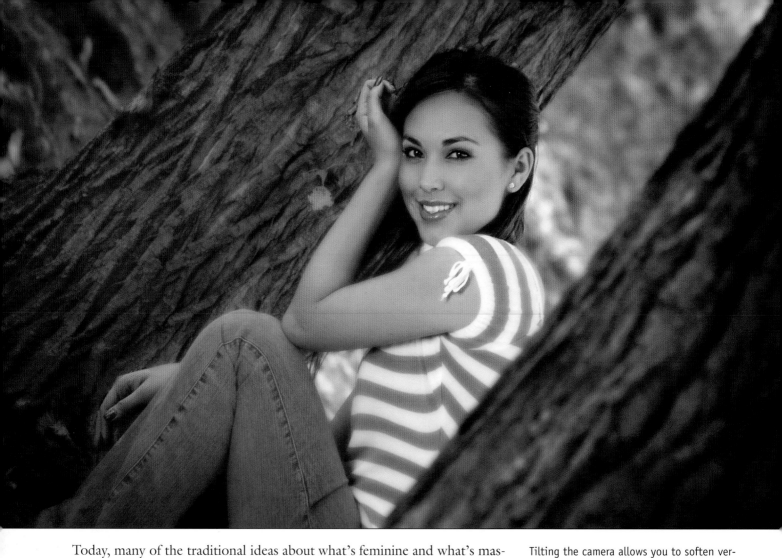

Today, many of the traditional ideas about what's feminine and what's masculine just don't apply. Plus, there are factors beyond gender that must be considered when selecting a background. For example, you will find that some scenes work better with more elegant types of clothing, while others are better suited to casual outfits.

Keep in mind that you aren't limited to using a scene in only one way. If you have strong vertical lines in a scene, for example, you can tilt your camera to make the lines more diagonal; this will change the feeling of the background. If the background has a great deal of detail but you need a softer feeling, open up the lens and the background will soften to produce the look you want.

Outdoor settings are typically easier to read than indoor locations. As a result, coordinating the clothing and posing to the scene to achieve an overall sense of style becomes easier. A typical park or garden scene is a more casual setting, therefore more casual clothing and posing are required. An outdoor setting with columns and fountains is obviously more elegant and requires more elegant clothing.

An important point for selecting a location is to look for more natural, ungroomed locations. If you go to an elegant garden, you may find blank

Tilting the camera allows you to soften vertical lines by rendering them as diagonals.

areas in your background between the ground and the lower branches of the shrubs and between the tops of the shrubs and the lower branches of the trees. This happens because the garden is pruned for a manicured, elegant look. In contrast, when you go to a large park or natural river area, everything merges together to fill in the background. The tall grass isn't cut so it reaches up to the level of the unpruned bushes and shrubs, which grow up to the level of the low-hanging tree branches.

When you go to a large park, everything merges together to fill in the background.

CHOOSE THE LIGHTING

With the dress and the location selected, the next step is to tailor the lighting. While this isn't a book about lighting, it is an important factor in achieving a portrait with a sense of style. When it comes to lighting portraits

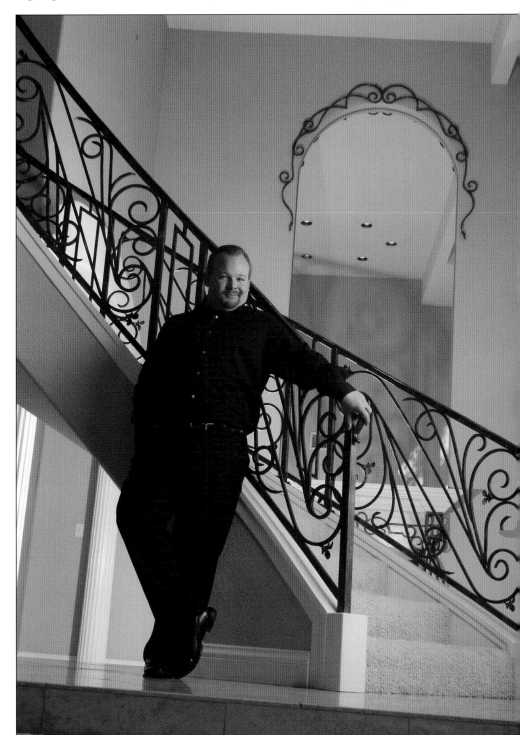

Shadows are your friends when creating portraits. They slim the subject and enhance the feeling of depth. If the ambient light in the setting you choose for your location portrait is too soft or lacks direction, you will need to modify it to create the effect you want.

outdoors, the major problem I see is lighting that is too soft and lacks direction. This usually occurs when the photographer uses an enormous area of open sky as the main light. This would be great as the fill source, but it doesn't provide enough direction to model a subject.

The "soft lighting is best" mentality developed in the 1980s and still prevails today. While soft light was ideal for film, it looks flat with digital; there just isn't enough contrast. Shadows are our friends when working to make our clients look their best. Shadows thin the face, slim the body, and increase the sense of depth in our portraits. Unless you're photographing models, your clients are probably far from perfect and will appreciate this effect. Deep shadows over a wide transition area can actually take ten to fifteen pounds off of an overweight person by slimming their face, arms, waistline, hip and thighs!

When working outdoors, you can reduce the size of the main-

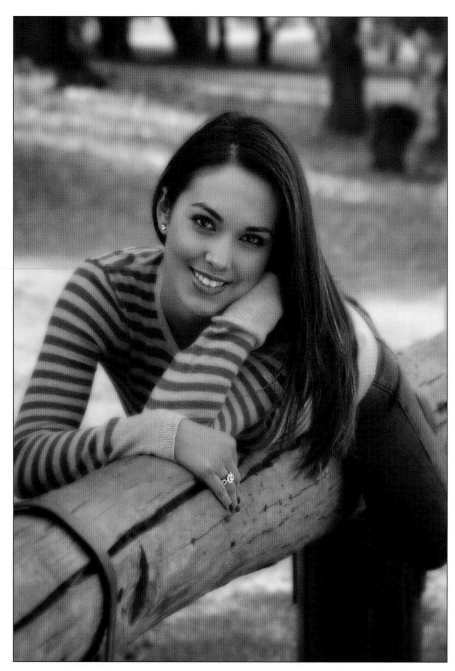

Without some shadows, the subject's face won't have any shape, and that's not a flattering look for most people.

light source by finding an obstruction (building, hedge, grove of trees, etc.). Then, pose the subject with their body turned toward the obstruction (the shaded area) and with their face turned back toward the main-light source. This sculpts the body and provides a thinner view. In most of my outdoor portraits, I actually use the ambient light in the scene as the fill. I then add reflectors, mirrored sunlight through a translucent panel, or studio flash for the main-light source.

CHOOSE THE STYLE OF POSE

Once you find out the purpose of the portrait, then you need to select a posing style that will be appropriate for the final portrait. Basically there are four

posing styles to work with: traditional posing, casual posing, journalistic posing, and glamorous posing. Within a single person's session you may use a variety of posing styles. This is a business decision you must make. But to learn posing you need to be able to distinguish between the various types of posing and know what type of situation each is suited for.

Traditional Posing. Traditional posing is used for portraits for business, yearbooks, people of power, and people of distinction. This style of posing reflects power, and to some degree wealth, respect, and a classic elegance. Whether these portraits are taken in a head-and-shoulders- or full-length style, the posing is more linear, with only slight changes in the angles of the body.

Traditional posing is subtle, involving only slight changes in the angles of the body.

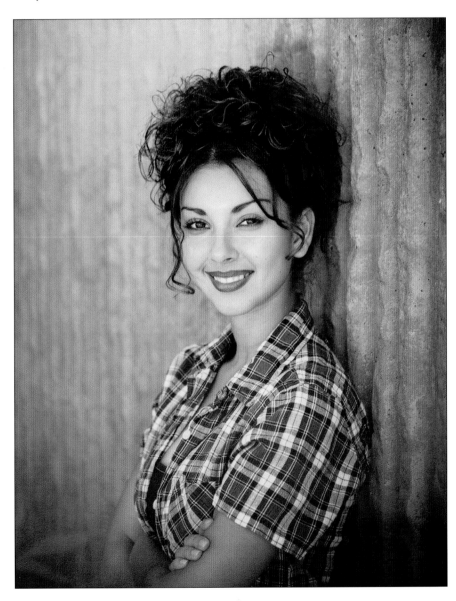

The posing needs to be subtle. Most of the time, these clients will feel more comfortable in a standing rather than a seated position because of the clothing they are in. The expressions should be more subtle as well. Laugh-

ing smiles are definitely not appropriate. But at the same time, serious expressions need to be relaxed. Most people taking traditional portraits aren't comfortable doing so, and therefore have a tendency to scowl. This needs to be avoided.

Casual Posing. Casual posing is a style of posing in which the body is basically positioned as it would be when we are relaxing. Observe people as they are watching television, talking on the phone, or enjoying a picnic, and you will see the most natural and best casual poses for your clients. Casual poses are most often used when the portrait is to be given to friends and family.

Casual poses are resting poses. The arms rest on the legs, the chin rests on the hands. The back is posed at more of an angle. It is common to use the ground to pose on, laying on the side or even on the stomach. The purpose is to capture people as they really are.

Journalistic Posing. Journalistic posing really isn't posing at all. It is recording people as they interact with their environment. It is capturing the child, bride, or family as they are engaged in an activity so they basically forget you are are recording their image. This is a very specific type of portrait and not one that the majority of people will respond to when it comes time to purchase, unless they have requested it and have a complete understanding of what the outcome of the session will look like.

Glamorous Posing. Glamorous posing is sensual or sexy; it makes the subject look as appealing and attractive as possible. I am not talking about boudoir or the type of glamour that achieves its look by having the client in little or no clothing. You can pose a fully clothed human being in certain ways and make them look extremely glamorous and appealing. If you finish the pose with the right expression, often with the lips slightly parted, you will have made the client's romantic interest very happy.

An excellent source of glamorous posing is found in lingerie catalogs, such as those published by Victoria's Secret or Frederick's of Hollywood. The photographers who create these images are masters of making the human form look its best. Your client will just have more clothing on.

Many of my traditional poses are much more glamorous in their look than what the average pho-

FACING PAGE—Casual poses are relaxed and natural. These are the kinds of poses best used in portraits created for the subject's friends and family.

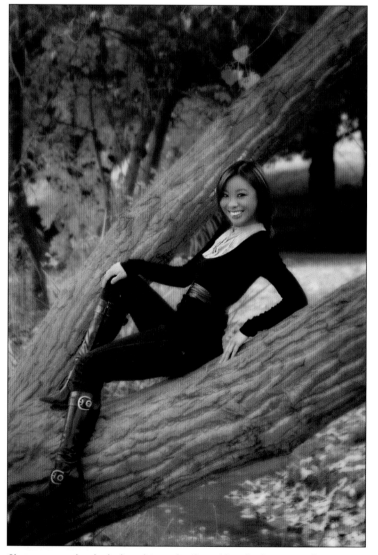

Glamorous posing is designed to make the subject look as appealing as possible. It is more dramatic and stylized than traditional or casual posing.

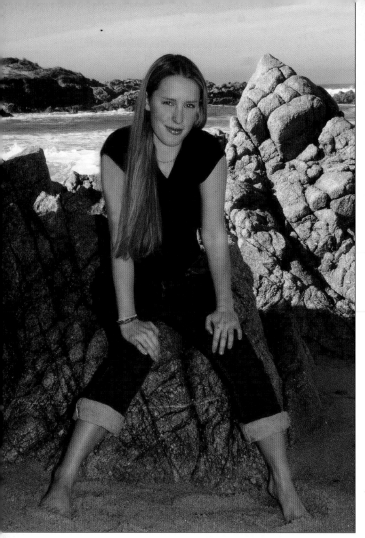
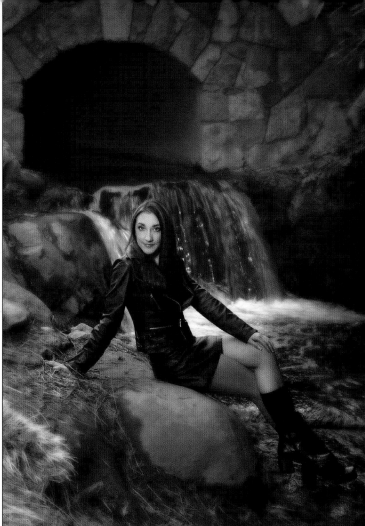

tographer would consider traditional. This is because, as human beings, I think we all want to appear attractive. People who say they don't care how they look are the same people who say they don't care about money—and I think that people who would say things like that would lie about other things, too!

ABOVE—The rocky scenes may be somewhat similar, but the poses and clothing are quite different. As a result the portrait on the left has a fun, casual feel, while the image on the right is more glamorous. FACING PAGE— Simple changes can totally change the look of a basic pose.

PRACTICAL EXAMPLE

With the clothing, scene, and lighting selected, it now is time to pose the subject. I show the client the poses by posing myself first. Yes, I get some very strange looks—especially when I demonstrate an elegant, full-length feminine pose—but if you can't pose *yourself* to look good in a pose, you have no chance of posing your *client*.

The second step is something I call variations. In every basic pose, there are variations that can be created simply by changing the hands or arms the angle of the head, the expression, or (in the case of full-length poses) the feet and legs. While clients do get a laugh at me as I model these variations for them, it helps them select the pose they like best. It is also good posing practice for me. Believe me, after running through poses for a few clients, you won't forget the most popular ones—and knowing all the poses in the world

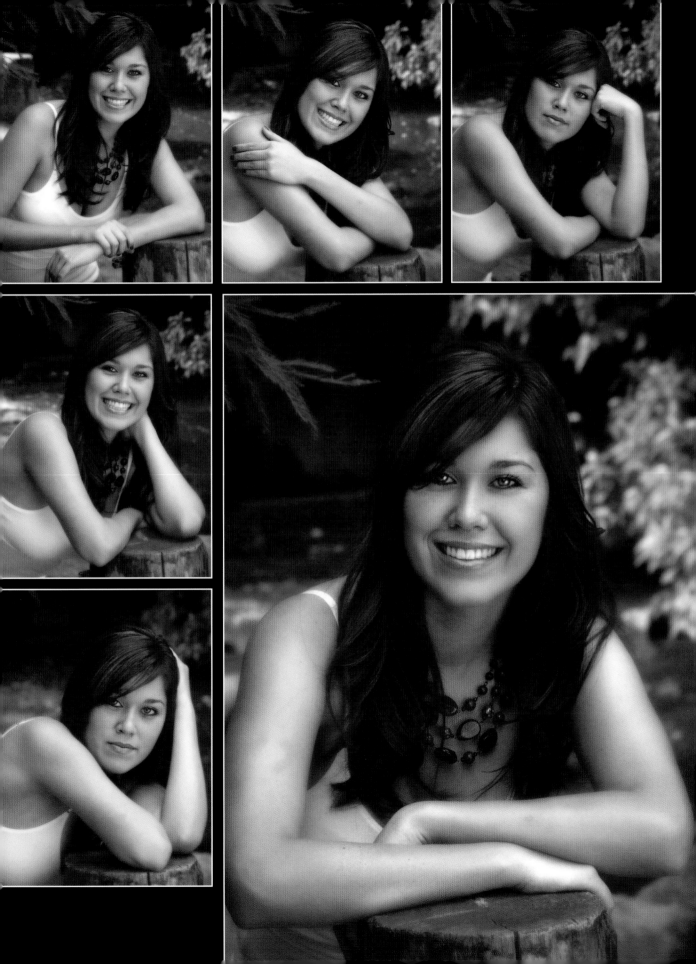

won't help you if you can't remember them! Many times I also think up new poses as I go through the variations.

Once the client selects the pose, we put to use the rules of posing the body. We will be covering these in chapter 3, but here's a quick overview. The first thing is to turn the body toward the shadow side of the frame to make sure the subject appears as trim possible. The arms will be posed away from the waist, slimming its appearance, and the legs will be posed so that one leg supports the body and the other creates an accent. The hands will rest on a surface (a tree trunk, leg, table, etc.) to make them more comfortable and appear naturally posed. Although flat shoes would be more comfortable, I ask women to wear high heels to make sure their legs and thighs look as good as possible. If this is not appropriate to the outfit, their heels should be raised (or toes pointed) to create the same effect. The subject's face is also turned back toward the main-light source for the best view of the eyes and to stretch any loose skin under the neck.

Now we are ready to pick up the camera. This is a key difference between students and professionals. Students start shooting right away, notice all the imperfections only when they see the final images, and then vow to correct them in the future. Professionals carefully study every aspect of the scene and only shoot when they are satisfied that everything is the way it should be to create a flawless portrait.

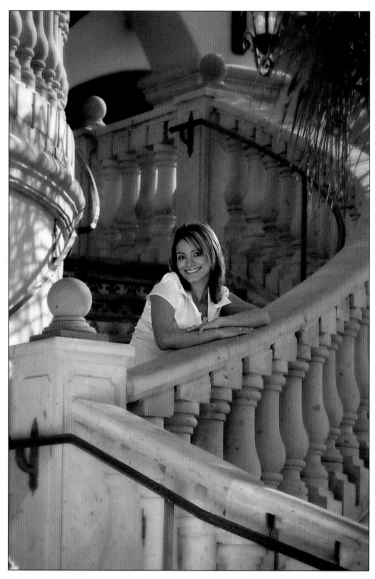

If you want the subject to smile, you must have a smile on your face, too. Subjects naturally reflect the photographer's mood.

Once the subject is in the pose and I have everything just the way I want it, I explain exactly what I want them to do. I tell them that the first shot is always a test—so it doesn't matter if they blink, smile, or even sneeze. After that, we will do a series of photos that are smiling, then a series of images with a relaxed expression, and then a few big cheesy smiles at the end. With each expression, I myself display the expression I want them to have (more on this in the next chapter).

It's important to remember that you are responsible for *everything* that appears in *every* frame of *every* session you photograph. Only when you take control of these elements will your portraits achieve a sense of style that will ensure your clients enjoy them for a lifetime.

3. Flatter the Client

Classic posing rules have their place, but the overriding concern must be that the client looks good and likes their picture.

In one chapter I am going to tell you how to pose every part of the human body. Isn't that amazing? Okay, I might be exaggerating—but I *am* going to give you some important tips for posing each part of the body to look its best. These are ideas that we will discuss further in subsequent chapters.

I want to start, however, by pointing out that some of my suggestions may be at odds with "classic" principles. In my experience, there is a difference between what you learn in school and what actually works in the real world. The poses that I was taught in my studies of classic posing didn't work—at least without some modification—for my clients and their tastes.

I think this is because most of the classic posing rules have become outdated. One reason for this is that the roles of men and women in our society

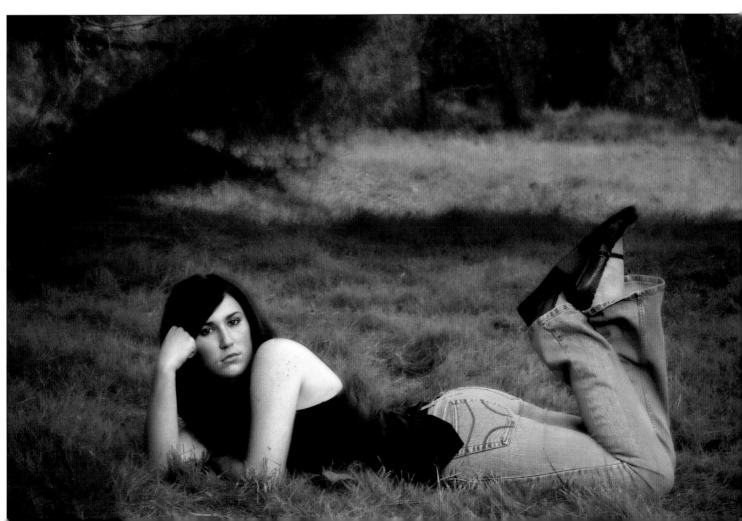

have changed. Men still want to look masculine, but they don't want to look rigid or emotionless. Women want to look feminine, but they don't want to look like doe-eyed creatures without a thought in their heads.

Additionally, the buying public doesn't want to look artificial in their posing. Outside of wedding photography, the average buyer of portrait photography is a woman between 35 and 60. She holds the purse strings, and she wants to see her family members as they really are. This is very obvious in senior photography and even in the photojournalistic style of wedding photography that many brides (and their mothers) prefer. This doesn't, however, mean that a bride doesn't want *any* posed portraits or that a senior's parent doesn't want at least *one* yearbook-style shot taken during the session.

The big exception to this trend toward the casual is in images with a fashion edge. Clients see this kind of imagery on television and in magazines, and they often love the edgy, dramatic, and unusual poses it features. A client who favors this kind of portrait expects to be posed to create an effect that is not natural looking or relaxed—something that is definitely not in keeping with so-called classic posing.

Images with a fashion look appeal to many clients and feature posing that is definitely not limited by classic techniques.

I am not saying that you should not learn classic posing. There are times when that type of posing is appropriate, and everyone has to start somewhere. I am simply sharing with you my experience from over twenty years of working with my clients; what you see in this book are the best-selling poses and ideas from a very successful studio. There are *many* ways in which you can pose the human body, ways that will complete the overall look of the image and make your client look beautiful.

BASIC GUIDELINES FOR POSING

Explain Problems with Tact. Potential problems need to be addressed at the start of the session. If you see that your client is a larger woman and you also see that she has brought sleeveless tops that you know will not be flattering, you need to explain, "One area that women tend to worry about is their arms—either the size of the arms or hair on the forearm showing in the portrait. This is why we suggest wearing long sleeves. Now, you can try one sleeveless top, but most woman stick to long sleeves just to be safe." This is

a nice way of telling your client, without embarrassing her, that her arms are too large for that kind of top. In referring to other clients and not specifically to her, you save her feelings and the final sale. You can apply these same principles to dealing with other appearance problems you may encounter.

Observe the Details. The key to good posing is being observant. Many photographers are in too much of a hurry to start snapping off pictures. I tell my young photographers to take one shot and wait for that image to completely download and be visible on the screen. At that point, I want them to study the image for at least ten seconds. By forcing them to take the time to notice problems in posing, lighting, and expression, the number of obvious problems have gone down considerably.

Many photographers find that they don't have an eye for detail. They constantly find problems coming out in the final proofs when they show them to the client—problems they should have picked up on before the portrait was even taken. If this is your shortcoming, hire someone with a good eye for detail to assist you in your sessions. Their eyes and focus on detail will save you the cost of their salary in lost or reduced orders. For example, we have a

The key to good posing is being observant. Catching problems before you shoot the picture will result in better images and less need for retouching.

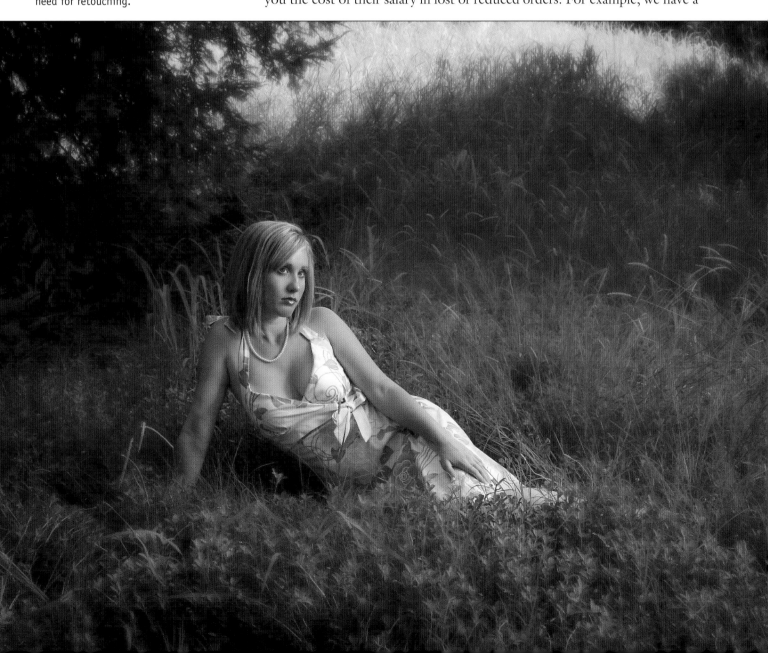

If you find that you don't have a good eye for detail or fashion, be sure that someone on your staff assists you. This is the only way to ensure client-pleasing images.

photographer who has been with us for some time. He, like most mature men, has no idea what makes one hairstyle look good and another look messy. Therefore, I pair him up with one of our younger posers/set movers, who acts like she is a member of the fashion police. She can spot a stray hair or a bad outfit from across the studio. Between the two of them, we have excellent portraits for clients.

Don't Rely on Digital Fixes. By the way, many digital photographers see a problem and think, "I shoot digital, I can fix anything!" Well, no—you can't. Once we went digital, it took our staff about six months to get out of the "we can fix anything" mindset. Every time an employee told a client we could fix something, I would sit them down at a computer station and tell them to fix it. When they were still working on it an hour later, I would ask if we could "fix anything" or not.

Time is money—and even if you *can* fix a problem in Photoshop, it isn't easy trying to get your client to pay extra for all the time it takes. Problems with posing need to be dealt with at the shoot, not fixed later. Your client also needs to know how to dress to look their best and hide their flaws before the session day. If they don't wear the clothing that you have suggested, then they must be billed for the time it takes to fix the problems that their decision created. This information has to be given to them verbally and in writing (in a session brochure) or in the form of a video consultation.

Problems with posing need

to be dealt with at the shoot,

not fixed later.

THE HEAD

Tilt. The head, and especially which direction to tilt it, is a bit of a mystery for some people. I receive many e-mails from photographers who get con-

fused about which direction (and how far) to tilt it. How I wish that every college teaching photography would just avoid this one subject. I have never seen one aspect of photography that so many photographers leave school doing so badly. I have had some truly talented photographers work for me, and that is the one obstacle I have had to overcome with almost every one of them.

Classic posing taught photographers to tilt the head toward the lower shoulder for a man and toward the higher shoulder for a woman. Essentially, tilting the head toward the lower shoulder shows strength, while tilting the head toward the higher shoulder makes the subject look more passive. So, by that standard, every woman would be photographed in a "passive" pose—and I guarantee that just won't work for a lot of your clients. Therefore, the real rule of tilting the head is that there is no rule. You don't *always* do *anything* in photography—especially nowadays. If you are photographing a woman, you don't tilt toward the high shoulder and you don't tilt toward the low shoulder, you tilt toward the shoulder that looks good and best fits the overall feeling desired in the final portrait.

The easiest way to learn about the head tilt is to first pose the body. Then, turn the face to achieve the perfect lighting and look. Then stop. If the person looks great (as about 80 percent of clients do), take the image. If the subject is very uncomfortable and starts tilting their head in an awkward di-

Here are two poses that are very similar aside from the tilt of the head. As you can see, the tilt just adds a different flavor to the shot.

rection, correct it. It's that simple. (*Note:* If the subject is nervous, they will instinctively tilt their head toward the high shoulder, making themselves look very awkward.)

When photographing a woman with long hair, I look to the hair to help decide the direction the head will be tilted and the direction the body will be turned. Long hair is beautiful, and there must be an empty space to put it. A woman's hair is usually thicker on one side of her head than the other. The tilt will go to the fuller side of the hair and the pose will create a void on the same side for it to drape into. This means she will sometimes be tilting toward the lower shoulder.

Guys typically, on the other hand, generally do look better tilting the head toward their lower shoulder or not tilting at all. But again, the pose and the circumstance dictate the direction the head is tilted or whether it is not tilted at all.

Long hair is beautiful,

and there must be

an empty space to put it.

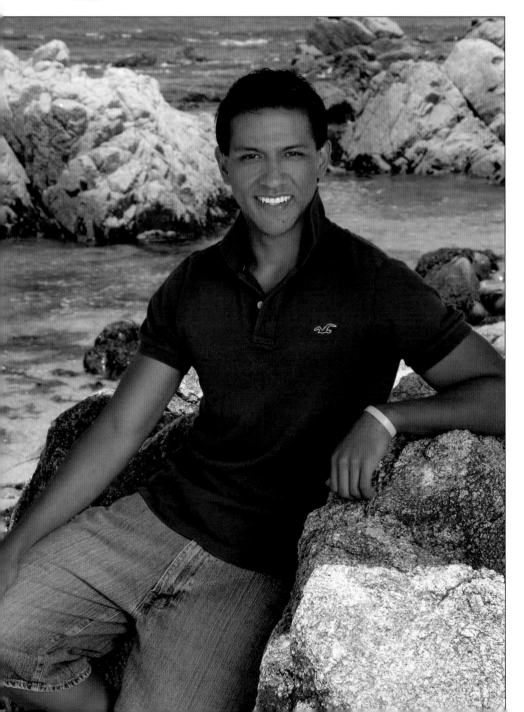

With guys, the head usually looks best tilted toward the low shoulder or not tilted at all.

Poses with direct eye contact are usually the most popular among portrait buyers.

If the eyes are not properly lit and properly posed, the portrait will not be salable.

When it comes to how much to tilt the head, less is better than more—especially if you are inexperienced. A little head tilt, even in the incorrect direction won't sink an otherwise beautiful portrait, but an excessive head tilt (unless it's to achieve a specific result) will ruin just about every photo, whether or not the head is tilted in the correct direction.

The Eyes. The eyes are the windows to the soul and the focal point for any portrait. You can create the most stunning pose in the most stunning scene, but if the eyes are not properly lit and properly posed, the portrait will not be salable.

Position of the Eyes. There are two ways to control the position of the eyes in a portrait. First, you can change the pose of the eyes by turning the sub-

ject's face. Second, you can have the subject change the direction of their eyes to look higher, lower, or to one side of the camera.

When the mouth smiles, the eyes must smile, too—otherwise the expression won't look natural.

Typically, the center of the eye is positioned toward the corner of the eye opening. This enlarges the appearance of the eye and gives the eye more impact. This is achieved by turning the face toward the main light while the eyes come back to the camera. This works well for all shapes of eyes, except for people with bulging eyes. When this is done on bulging eyes, too much of the white will show and draw attention to the problem.

Eye Contact. The point at which you ask the subject to focus their gaze in respect to the position of the camera's lens also, in essence, poses the eye. First and foremost, the subject should always be looking at someone, not something. To do this, I put my face where I want their eyes to be. There is a certain spark that the eyes have when they look into someone else's eyes that they don't have when they are looking at a spot on the wall or a camera lens.

Usually, I position my face directly over the camera. This puts the eyes in a slightly upward position, increasing the appearance of the catchlights (see page 39). If the camera position is too high to make this possible, I position my face on the main-light side of the camera, never beneath it and never to the shadow side of it. Both would decrease the catchlights.

With my face directly to the side of the camera, the eyes appear to be looking directly into the lens, even though the subject is actually looking at me. When looking from the side of the camera, a common mistake that my new photographers make is getting their face too far from the camera. This makes the eyes of the subject appear to be looking off-camera—which is fine if that is the intention and not a mistake.

When the eyes of the subject look into the lens (or very close to it), the portrait seems to make eye contact with the viewer. An overwhelming majority of our senior clients prefer the intimate feeling of eye contact as opposed to the more reflective portraits where the eyes look off-camera, but

Having the subject look at your eyes (rather than a spot on the wall or some other inanimate object) gives their eyes more spark in the portrait.

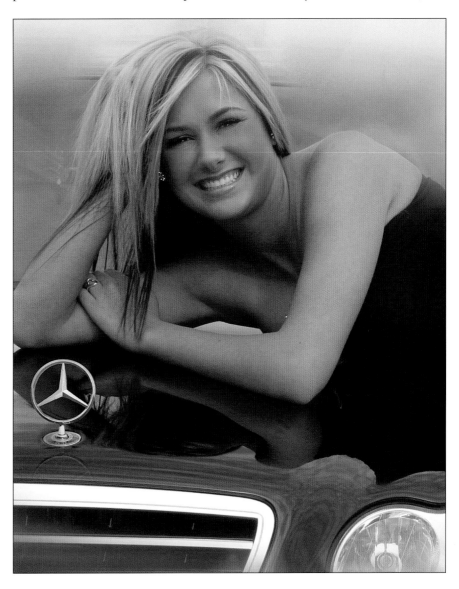

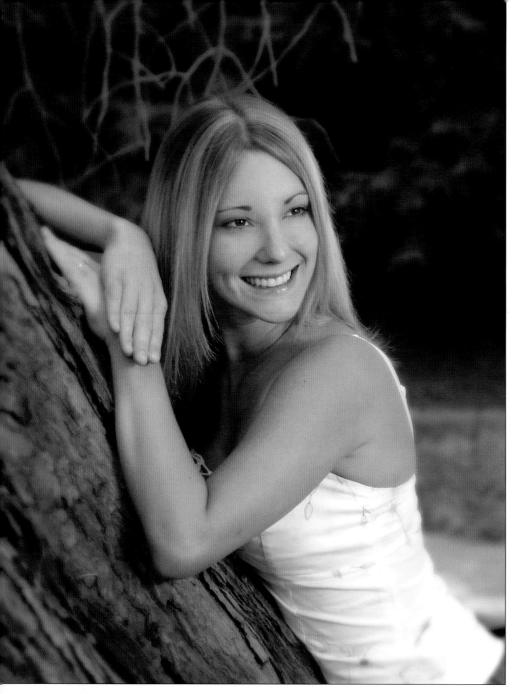

Reflective poses show the subject looking off camera.

this is our clients. You need to offer both styles of portraits and discuss with your clients what is right for them.

Reflective Poses. Reflective posing works well in a storytelling portrait—a bride glancing out a window as if waiting for her groom, a senior glancing over the top of a book and thinking of the future, etc.

If the eyes are to look away from the camera, there a few rules that need to be followed. First of all, the eyes should follow the line as of the nose. It looks ridiculous to have the eyes looking in a different direction than the nose is pointing. This goes for poses with the subject looking just off-camera, as well as for complete profiles. Also, as you turn the face away from the camera, there comes a point where the bridge of the nose starts to obscure the eye farthest from the camera. At this point, you have gone too far. Either go

There comes a point where the bridge of the nose starts to obscure the eye farthest from the camera.

into a complete profile, showing only one eye, or bring the face back to provide a clear view of both eyes.

Catchlights. Outdoors, the single biggest mistake I see photographers make is not having the proper catchlights in the subject's eyes. This usually comes from working with light that has no direction. In almost all of my portraits, I use a small reflector near the subject to ensure there are beautiful catchlights in both eyes. If you evaluate the catchlights, you can often diagnose any problems with your lighting. If each eye shows a distinct catchlight in the proper position, your main light is good; if the catchlights aren't right, neither is your main light. Usually, this means your light lacks direction, indicating that the main light source is too large and too soft.

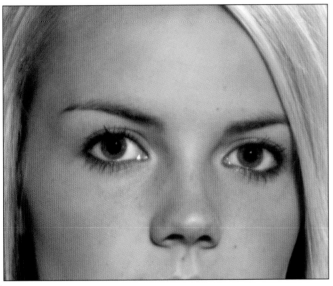

With no direction to the light, catchlights are absent and the eyes have a dull look.

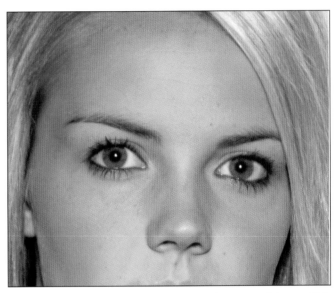

On-camera flash creates a tiny catchlight in the center of the eye. This is not the ideal position.

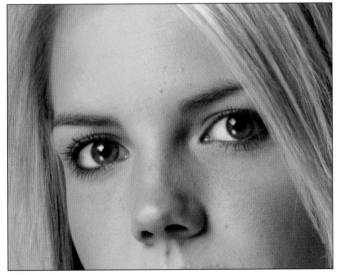

The top catchlights are in the proper position and a reflector below the subject has produced a second catchlight. This smooths the skin, softens any darkness under the eyes, and produces a glamorous look.

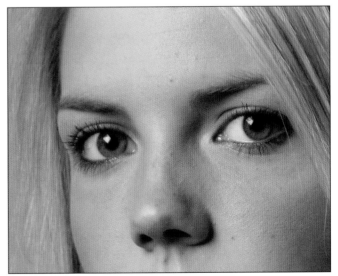

In this final image, the catchlights are strong, well defined, and located in the proper position on the eye. This is the result you want in a professional-quality portrait.

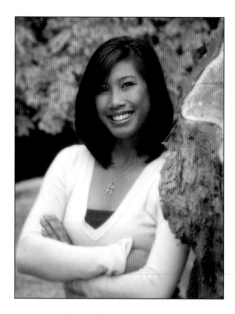
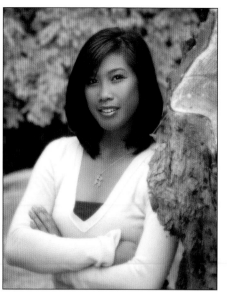
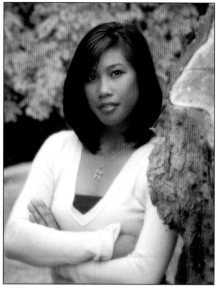

Mouth and Expression. The mouth must be, for lack of a better word, "posed" properly. Don't ever forget the old saying: expression sells photographs. I want clients to relax and let their expressions come naturally.

I start off each session by explaining what I will be doing and how I want them to smile—as well as how not to smile. I typically say, "The average person smiles 150 times a day and it looks beautiful and natural, because you're not thinking about it and not being told how to do it." (That part of the speech is for the mothers who turn into smiling cheerleaders, making their children extremely self-conscious about smiling.) I then continue, "When it comes to the non-smiling photos, most people will go from big natural smiles to pressing their lips tightly together. The only time people who know you see you with your lips pressed tightly together is when you are upset, so they will say you look mad in all your non-smiling photos." (Note that I do not call these "serious" photos; I stick to the phrase "non-smiling.") This explanation might seem rather long-winded, but it helps the client start to relax and understand that it is my job to make them look beautiful.

People naturally mirror the expression of a person with whom they are interacting, so the second tip for great expressions is to have on your own face the expression you want your client to have. When you want them to smile, you yourself should smile and speak with more enthusiasm. When you want a relaxed expression, speak with a softer tone and without smiling. If you do this, you will quickly see the expressions in your portraits improve.

Also, I suggest that you take twice as many smiling photos as non-smiling ones. While many photographers choose non-smiling photos for display, smiles outsell non-smiles four to one.

Hair. We've already looked at how a woman's hairstyle can help you determine the best way to tilt her head, but there are a few other things to consider.

I suggest taking images with a variety of expressions—but take more smiling photos than non-smiling ones. Smiling photos are always the top sellers.

People naturally mirror

the expression of a person

with whom they are interacting.

LEFT—The full part of the hair can be pulled over the shoulder farthest from the camera. This shows its length and texture without distracting from the face. FACING PAGE—Tilting the head toward the side of the head where the hair is fullest (the side opposite the part), gives long hair a place to fall into between the head and the shoulder.

The hair can't strike a pose, but you as a professional are responsible for ensuring that your subject's hair isn't in their eyes or creating a shadow over any part of the face. Longer hair also must be positioned so that it does not overpower the face on the side that is closest to the camera. Generally, this means pulling the fuller side of the hair forward over the shoulder that is farthest from the camera.

You should also check for stray hairs or strands of hair that separate from the body of the hair; these can be very distracting. Many times, men and woman with short hair have curls that peek out from behind the side of their neck or their collar. This is another case where you need to make sure the hair doesn't draw attention to itself.

Longer hair also must be

positioned so that it does not

overpower the face

CHIN AND NECK

The chin and neck area is probably the least photogenic of the body. It is the first area to show age in older people and the area that shows the first signs of weight gain for many. I have three suggestions for this part of the body. First, you can hide it. This can be done by resting the chin on the subject's arms, hands, or shoulder. Second, you can stretch this area by rotating the body toward the shadow side of the frame and turning the face back toward the light. If these two strategies prove ineffective, try option number three. With today's heavier clients I use the "turkey neck." In this pose, the subject extends their chin out toward the camera and then lowers their entire face. This stretches out a double chin and then hides it behind the lowered face. In extreme cases, I will raise the camera angle to avoid seeing this area.

The chin and neck area is probably the least photogenic of the body.

A pose like this naturally conceals the neck and chin area.

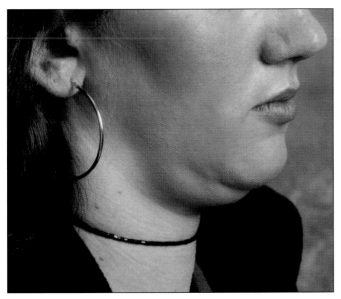 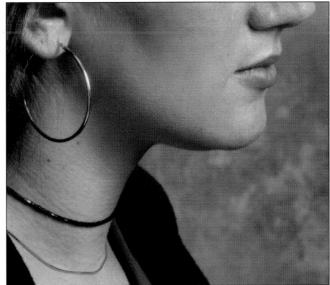

Here seen from the side, the "turkey neck" pose helps stretch out the area under the chin for a more flattering appearance.

SHOULDERS AND SPINE

The widest view of any person is when the person is squared off to the camera. By turning the shoulders, waist, and hips to a side view, preferably toward the shadow side of the frame, you create the thinnest view of the body—and we all want to look as thin as possible.

The shoulders of a man should appear broad and at less of an angle than the shoulders of a woman. Women's shoulders can be a very appealing part of a portrait if posed properly. I like when my wife wears dresses that show off her shoulders. However, my wife is thin and very fit, unlike the majority of people we photograph each day.

For this reason, it is always a good idea to have the shoulders covered with clothing if the subject's weight is at all an issue. Clothing itself, however, can create problems in this area of the body. Large shoulder pads in a jacket, for example, will make just about any kind of posing impossible, making your client look like a football player. As you can imagine, this is good for skinny guys but not so good for larger guys or any woman.

By posing the person reclining slightly backwards or leaning slightly forward, the shoulders and spine go diagonally through the frame and achieve a more relaxed look. The portrait will have a professional look and it will be more visually appealing. It will also create a more flattering impression of the subject's personality. This could be called the "anti-stiffness" rule. When you see a portrait of a person in which their shoulders are running perfectly horizontal through the frame, or in which the spine (if you could see it) is running perfectly vertical in the frame, the person appears stiff. Visually, you are telling everyone who sees this portrait that your client is uptight and very rigid.

Keep in mind that the subject's shoulders also form the compositional base for every head-and-shoulders pose you take. Therefore, the line of the shoul-

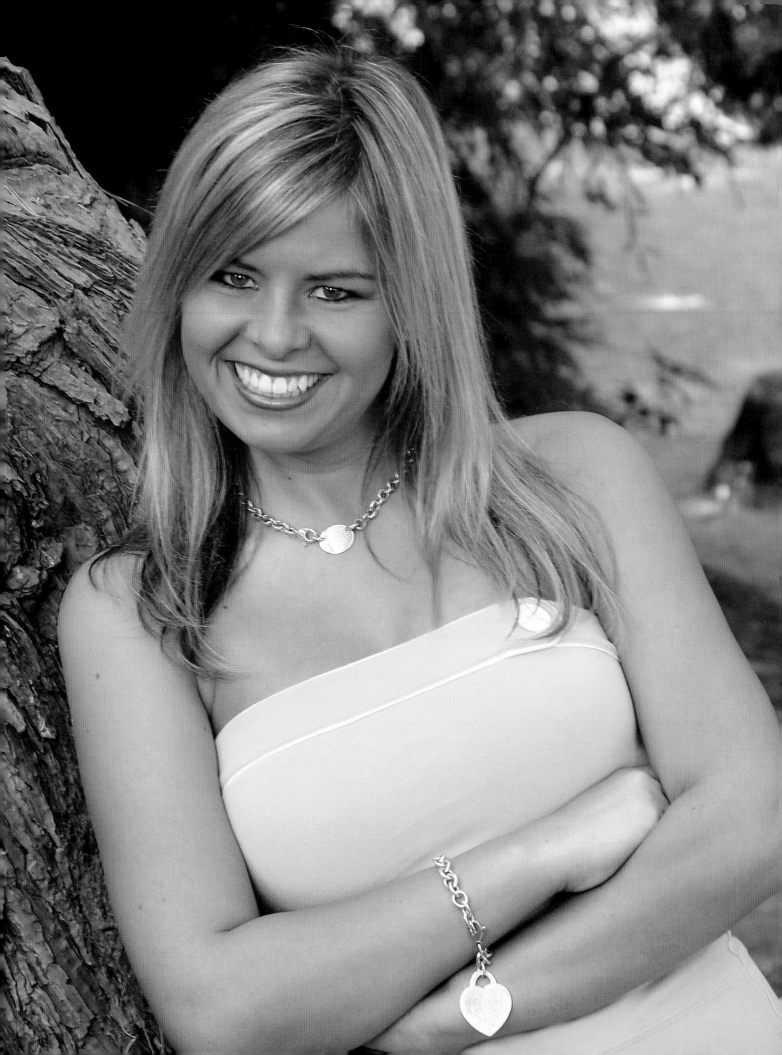

FACING PAGE—Posing the shoulders at an angle creates an appealing base for your head-and-shoulders portrait. It also makes the subject look more relaxed. **RIGHT**—If the appearance of the subject's arms or shoulders is at all a concern, long sleeves are a good option.

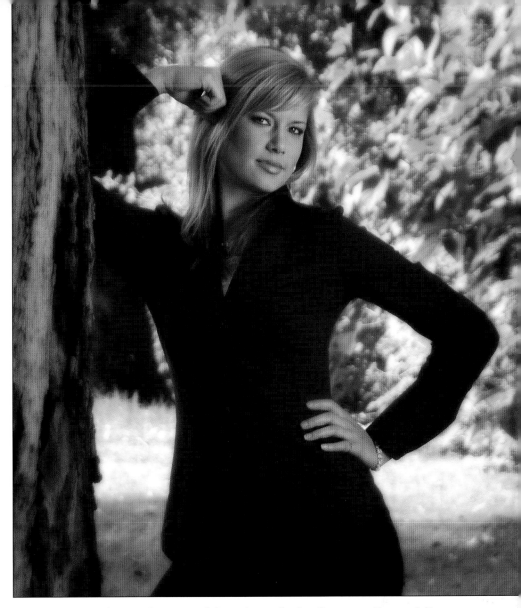

ders shouldn't form a horizontal line through the frame; a diagonal line makes the portrait more interesting and the subject less rigid.

ARMS

The arms complete the composition in poses taken from the waist up, so it is important to pose them carefully. This starts by keeping them separated from the waistline. If you do not, you will enlarge both the arms and the appearance of the waist.

Long Sleeves. Arms often have problems that can only be hidden by clothing, which is why I suggest that everyone wear long sleeves. Models may have perfect arms, but our clients are plagued with a variety of problems—arms that are too large or too bony, loose skin, hair appearing in embarrassing places, stretch marks, bruises, veins, etc. If weight is an issue, I also suggest that the client wear long sleeves in a darker color.

Posing the Arms. To learn how to pose the arms, watch people as they are relaxing. They fold their arms, they lean back and relax on one elbow,

Arms often have problems that can only be hidden by clothing.

they lay on their stomachs and relax on both elbows, or they use their arms to rest their chin and head.

Any time weight is put onto the arms (by resting them on the back of a chair, the knee, etc.) it should be placed on the bone of the elbow or the hand. If weight is put on the forearm or biceps area, it will cause the area to mushroom and appear much larger in size than it actually is. This is another reason to have the arms covered if it at all possible.

Using the Arms to Conceal Problems. Posing the arms carefully also gives you the ability to hide problem areas, such as the neck, waistline, or hips. I look at the client once they are in the pose to see if there are any areas that, if I were them, I wouldn't want to see. If there is a double chin, I lower the chin onto the arms to hide it. If I see a not-so-flat stomach, I may extend the arms out to conceal it.

HANDS

Hands are probably the hardest areas for most photographers to pose comfortably. In most old posing guides the hands look anything but natural, yet these poses still fill many wedding albums today. Other photographers hide the hands in almost every portrait—or just let them hang at the client's side. Neither of these approaches could really be described as achieving the pinnacle of artistry, to say the least.

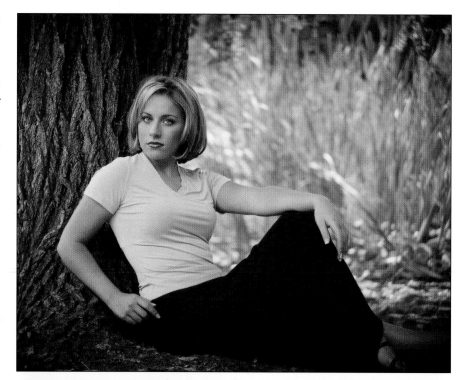

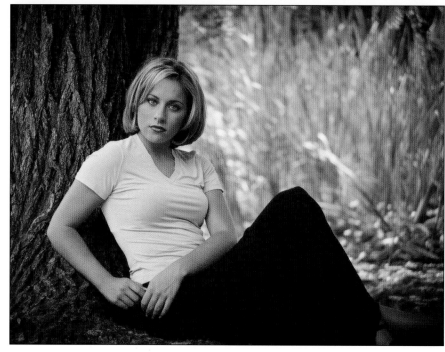

ABOVE—Moving the arm from its raised position (left) to drape across the stomach area (right) is a simple way to conceal an area that many clients don't want to see. FACING PAGE—Observing the way people really hold their hands will often give you good ideas for natural-looking poses.

Bend Every Joint? When I first started in photography about twenty years ago, the hands were supposed to have every joint bent. As a result, it wasn't uncommon for a woman to look like she'd missed a payment to her bookie and he took a nutcracker to her fingers.

Let's face it, the "all joints bent" look is a little on the unnatural side—I don't know about you, but I never have every joint in my hand bent. Using

this strategy makes your subject look like a mannequin from the 1960s. Also, when you have the hands posed in such a way, it can draw attention away from the face, the intended focal point of the portrait. While this works well for showing off a wedding ring (or, I suppose, if you are photographing a very homely person with beautiful hands), it is a major distraction for most of your buying clients. Forget about bending every joint and look at the way people place their hands while they are watching television, reading, or resting. There is a volume of posing ideas all around you. All you have to do is pay attention.

Give Them Something to Hold or Rest On. Generally, the hands of both men and women photograph best when they have something to hold on to or when they have something to rest on. They photograph worst when they are left dangling. The hands are one area of the body that clients usually pose very well on their own, if you explain where they are to place them

Hands look best when they have something to hold or something to rest on.

or what they are to hold. If you watch people relaxing, in fact, you'll see that they tend to fold their hands or rest them on their body—instinctively avoiding the uncomfortable and unflattering "dangling" positions.

Place the body and arms where you want them, then find a place for the hands to rest, or something for them to hold. Hands hold and they rest, they shouldn't look like they are broken or take on the shape of a cow's udder (with the fingers hanging down). Following this rule simplifies the entire process, allowing you to achieve quick and flattering results while avoiding the very complex process that many photographers go through when posing the hands.

Fists. Guys don't always have to have their hands in a fist—and if they do, it should be a relaxed fist that doesn't look like they are about to join in on a brawl. If the knuckles are white, the fist is too tight.

Women should never have a complete fist. If a woman is to rest her head on a closed hand, try having her extend her index finger straight along her face. This will cause the rest of the fingers to bend naturally toward the palm, without completely curling into it. Even the pinky won't curl under to touch the palm.

BUSTLINE

There are only two times when photographers need to concern themselves about this area. One is when a client wants her bustline to appear larger (as would be desired for a personal portrait to give a husband or boyfriend). The other is when you have a client who selects an outfit that is more revealing than it should be for the type of portrait she is doing. If you are running for political office, you don't want six inches of cleavage in your portraits (unless, I suppose, you are trying to increase the number of male voters!).

Hiding or enhancing the bustline or waistline really comes down to two factors: controlling highlights and shadows, and finessing the position of these body parts with respect to the main light. If the appearance of a large bustline would be completely inappropriate for the type of portrait being taken, dark clothing will help reduce the appearance of size. This is also an effective strategy for concealing a larger stomach area. With black especially, the distinct contours (the areas of highlight and shadow) that shape a bustline or belly don't show, making them seem smaller and flatter.

In the bustline, size is determined by the appearance of shadow in the cleavage area or the shadow cast underneath the bustline. To increase the shadow in the cleavage area, you simply turn the subject away from the main light until you achieve the desired effect. To really make this area stand out, skim a kicker light from the side of the subject over both breasts. You won't be able to miss this area of the body when you look at the portrait. Using logic, to reduce the appearance of the bustline, you would simply reduce or

eliminate the shadows in the same areas. This can be done by simply turning the body of the subject toward the main light.

WAISTLINE

Remember the old adage: no one is ever rich enough or thin enough. The waistline will appear wider if it is squared off to the camera and will appear thinner if it is turned to the shadow side of the frame for standing poses.

The minute I have a client sit down, I want to hide the waistline from view. As you will see in most of the portraits in this book, if the client is doing anything but standing, the waistline is obstructed from the view of the camera; in a seated position, the waistband of the pants will cut into even the thinnest waistline. If the seated person is thin, instead of covering the waistline you can have them straighten their back almost to the point of arching it. This will help flatten out the stomach area.

Now, imagine you are in a session with a man who works out and has a washboard stomach. If he wants to show off his muscles in a portrait for his wife, you could have him put on a jacket with no shirt underneath and leave it open. You would also want to use both lighting and posing to bring out the

Photographing the body at an angle (right) creates a much more flattering view than photographing it straight on (left).

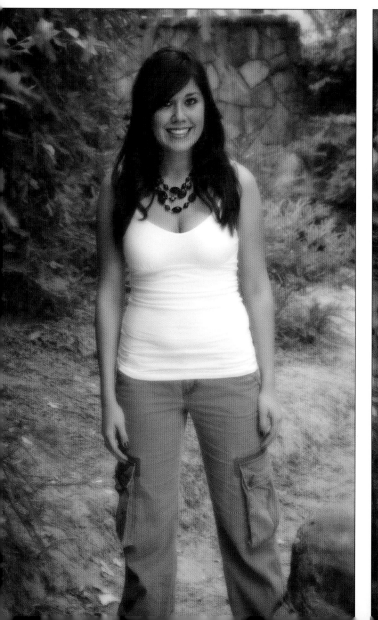
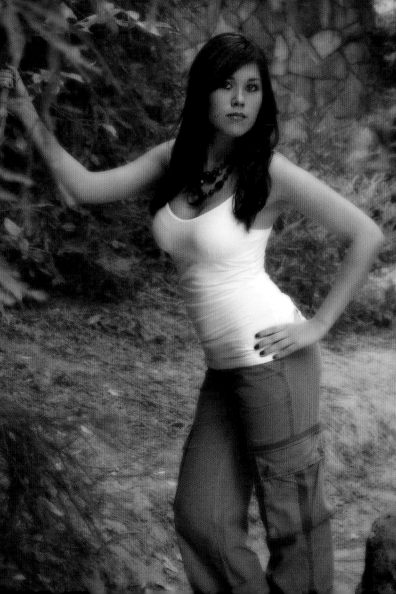

Here, the subject straddles a log and leans far forward—another possible pose for concealing the stomach area.

You'll want to eliminate shadows on this area by turning it toward the main light.

texture of the muscles in his stomach area. Simply turn the subject away from the main light to enhance the shape of this area.

Let's imagine, however, that a second man comes in who is—well, we won't say he's overweight, but he's eight to twelve inches too short for his current weight. If you show his stomach, you'll make him look like he's nine months along and expecting twins. In this case, the prudent thing to do would be to hide his stomach completely, which you can do with careful lighting and posing, and by pairing dark-colored clothing with a dark background. As noted above in our discussion of the bustline, you'll want to eliminate shadows on this area by turning it toward the main light.

HIPS AND THIGHS

This is probably the most important part of the body if you photograph women. While men gain weight in their double chins and stomachs, woman

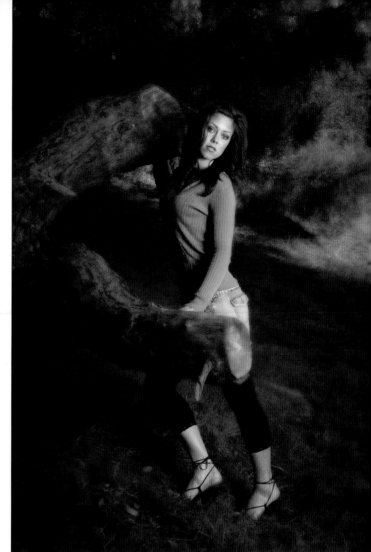

gain weight in their hips and thighs. Unless you are a woman or live with a woman, you never will realize how much women worry about this part of their bodies.

The majority of portraits should not include this part of the body. For any client with whom weight is a serious issue, it is especially important that you guide them away from poses that show the hips and thighs. Notice I said "guide." Some photographers use about the same amount of tact as a football coach. On a good day, a client can expect to hear things like, "Well, with hips like yours . . ." or "You are a little hippy, so we probably shouldn't show them in the photograph."

Anytime you have to talk with a client because what she wants to do isn't what she needs to do to be happy with her session, you should use past clients as an example. A good way to explain that full-length poses shouldn't be taken would be, "Most woman go shopping for an entire outfit, and for that reason they want to take poses full length. However, a lot of women worry about their hips and thighs appearing heavy, so usually it is best to take the poses from the waist up. Now, is there anything you would like to do full-length, or do you want everything from the waist up?" Saying this, any

The majority of portraits

should not include

this part of the body.

woman who worries about weight will automatically choose to take everything from the waist up.

With carefully chosen words, clients can easily be led in the proper direction. As I've noted previously, I demonstrate poses and posing variations for my clients. If I know one of the poses would be best suited for the client, I use the same tactic described above. When I get to the pose that will slim their hips, I simply say, "Most women worry about their hips and thighs looking as thin as possible. Posing *this* way, the hips and thighs look thinner. Now, which pose would you like to do?" Without exception, the slimming pose is the one that all but the thinnest clients will select.

Standing Poses. The first basic rule is never to square off the hips to the camera. This is obviously the widest view. In standing posing, rotate the hips to show a side view, turning them toward the shadow side of the frame if weight is at all an issue. Photographers often shift the weight of the hip to accent the one closest to the camera. This works with a very thin or very curvy

> With carefully chosen words, clients can easily be led in the proper direction.

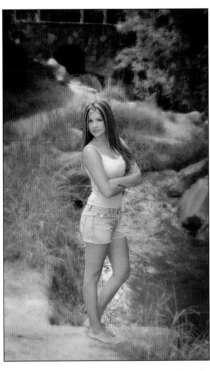

In standing or seated poses, placing the subject's body at an angle to the camera produces a slim look.

woman, but it enlarges the bottom and thigh, which isn't salable for 90 percent of women.

Just as the arms shouldn't be posed next to the body, legs (at the thighs) should never be posed right next to each other in standing poses. There should always be a slight separation between the thighs. This can be done by having a client put one foot on a step, prop, or set. Just turn the body to the side (the shadow side of the frame), and have the client step forward on the foot/leg that is closest to the camera. Alternately, you can simply have the client turn at an angle to the camera, put all their weight on the leg closest to the camera and then cross the other leg over, pointing their toe toward the ground and bringing the heel of the foot up. This type of posing is effective for both men and women.

Clothing also plays an important role in the appearance of the hips and thighs. The baggy clothing that has been popular for the past few years, and dress slacks for both men and women that are much less than form fitting, can sometimes make the thighs appear to be connected.

ABOVE AND FACING PAGE—Here we have everyone's favorite posing aid: a rock—but when you have a young lady lean against it or sit on it, the hips and thighs widen. Just rotate the subject and have her rest her weight on her hip bone. The resulting look will be much more pleasing.

Seated Poses. More can be done to hide or minimize the hips and thighs in a seated position than in a standing pose, but there are still precautions that need to be taken to avoid unflattering poses.

If you sit a client down flat on their bottom, their rear end will mushroom out and make their hips and thighs look even larger. If, on the other hand, you have the client roll over onto the hip that is closest to the camera, their bottom will be behind them and most of one thigh and hip will hidden. (Although this is an excellent rule, it is one that you may think I am breaking throughout this book. I do, in fact, have young ladies sit flat, but only when their knees are raised to make the body weight come down on the tailbone rather than the fleshy part of the body, or when the legs will hide the bottom from view.)

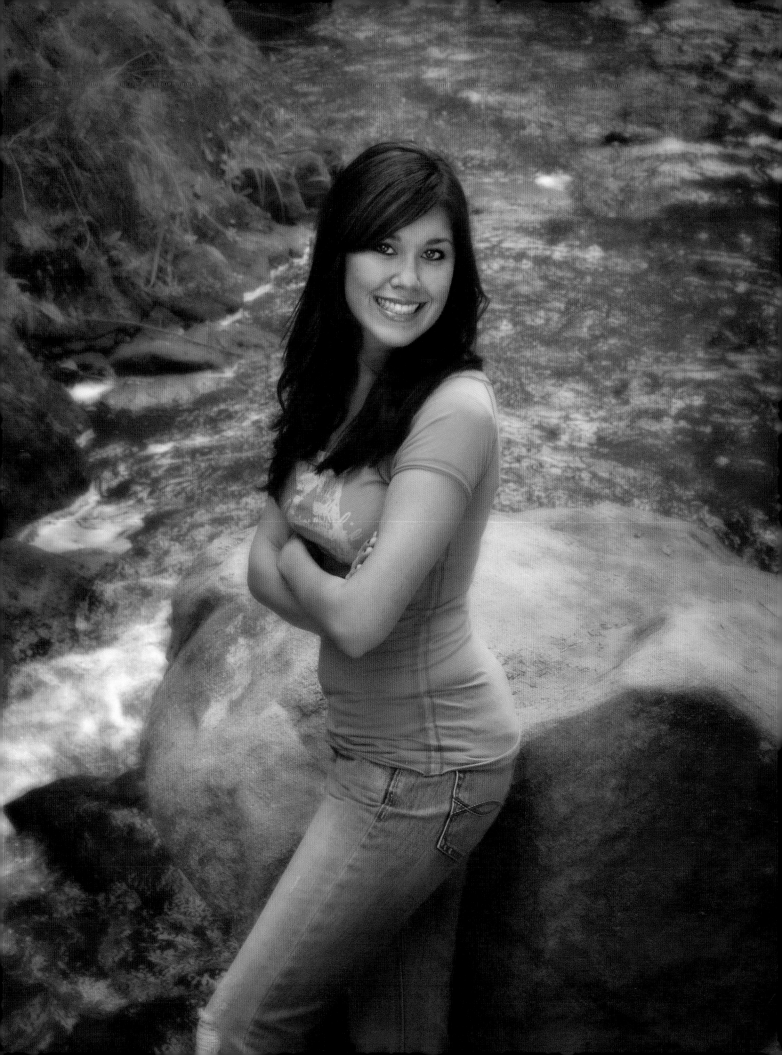

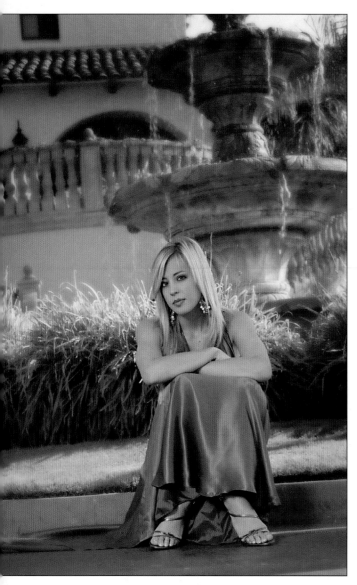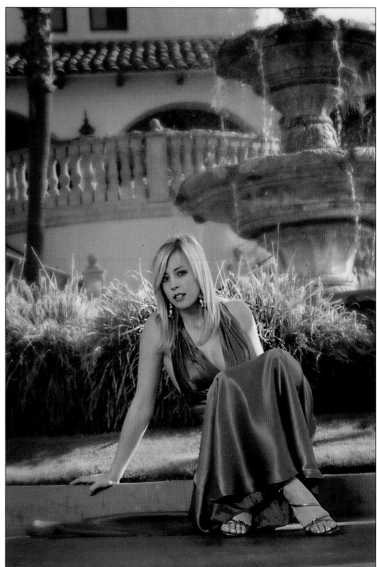

The thighs must be separated, if possible. Obviously, if the client has on a short dress, this isn't possible. Instead, simply have her move her lower leg back and bring her upper leg over the top of the lower one. If pants are worn in this same pose, the back foot can be over the front leg and the foot can be brought back toward the body, causing the knee to raise, again achieving a separation between the legs.

When you separate the thighs, in this or any other pose, you need to make sure that the area between the legs (the crotch area) isn't unsightly. In the aforementioned pose, you may find this problem occurring when the subject is wearing baggy jeans. The problem also occurs when you have a guy seated with his legs apart, then have him lean forward and rest his arms on his knees. The pose works well because this is the way guys sit—and it sells well because it looks comfortable. The problem is that the crotch area is directly at the camera. In this situation, you can use the camera angle and the arms to hide or soften the problem area.

ABOVE—When the knees are raised, you can have the subject sit flat on her bottom, as this area will be concealed by the legs. You can also shift the weight onto one hip. **FACING PAGE**—A high camera angle can help keep the emphasis on the face and off the hip and leg area—especially when the lower part of the body blends tonally with the background.

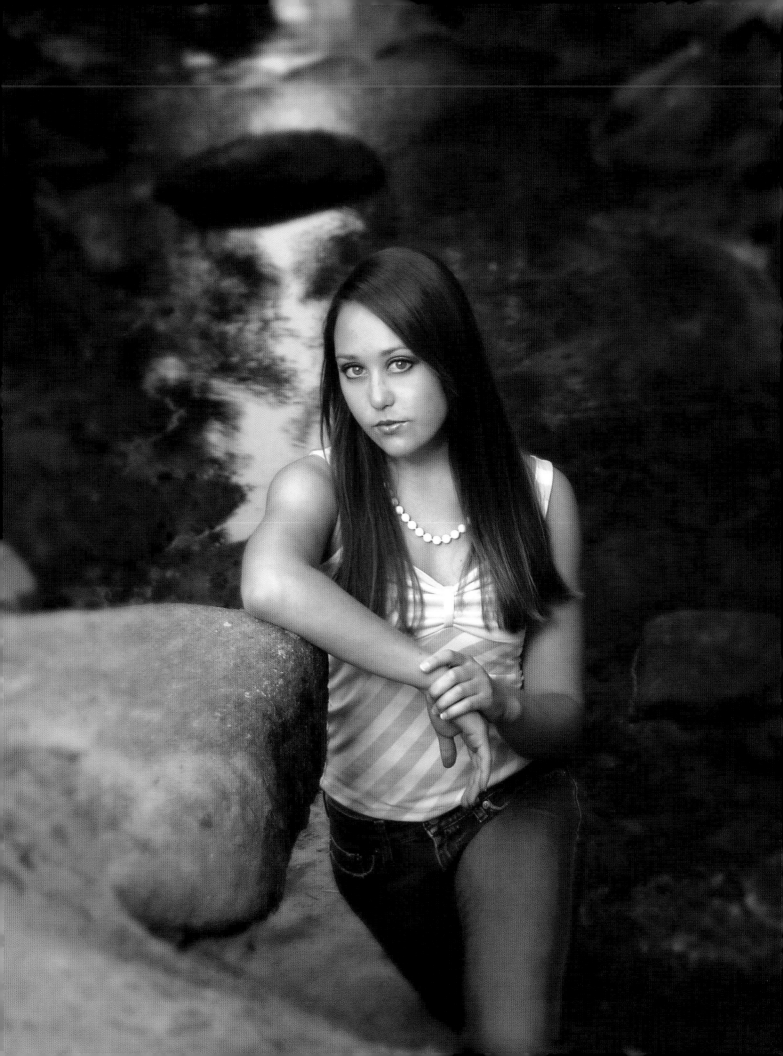

LEGS

To a woman, the appearance of her legs is just as important as that of her bustline. The standard of beauty dictates to women that their legs must be long and lean.

Ankles. This area is not a problem for most guys, but it can be a real issue for many women. The "cankle" (or the appearance of not having an ankle, but the calf of the leg just connecting to the foot) is a look that many women have and most could live without. This affliction is best handled by suggesting pants, looking for tall grass to camouflage the area, or taking the photographs from the waist up.

Muscle Tone. Legs appear toned when the muscles that run along the outside of the thigh and calf are flexed and visible. (If the client's legs are very heavy, however, the muscles won't be visible even when flexed and the leg won't look toned.) These muscles usually become more readily apparent when the heels are raised, as they are in high-heeled shoes or when the client is posed with her heels elevated.

Legs are one of those areas of the body (like cleavage) that a woman either has, or doesn't. Let me make this clear: I am not saying that most of your clients don't have legs, but many of your clients shouldn't show them. Just because a woman is the correct gender, doesn't mean she looks good wearing a dress. When this is the case, it's time for some tough (but tactful) love.

Color and Nylons. If any part of the legs show, they should appear to have color—porcelain skin doesn't work on legs. If the subject's legs are very pale, suggest that she bring nylons (obviously, this is not an option with some outfits, however). Darker nylons tend to look more elegant, while the flesh-toned ones look more "everyday."

Posing Techniques. When posing the legs, there is one simple rule that will help demystify the whole process: you have two legs to work with—one leg is the support leg, which holds up the body weight, the other leg is the accent leg. The accent leg is separated from the support leg and adds interest to the portrait. This accent leg visually lengthens the legs and gives the appearance of muscle tone. If you use this strategy, you will have cut your work in half, since you'll only need to pose one leg instead of two.

There are numerous ways the accent leg can be posed, as you can see in the photos on the facing page. Take the classic "James Bond" pose. In this stance, the weight is put on one leg and the accent leg is crossed over with the toe pointing down (facing page, bottom right). Turning the accent leg to the side (rather than having the toes pointing at the camera) will make the pose look even more interesting and further flatter the legs.

Even in a seated pose, one leg normally extends to the floor in order to, for lack of a better word, "ground" the pose. Have you ever seen a person

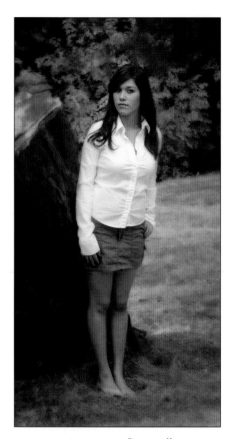

ABOVE AND FACING PAGE—In standing poses, having the legs side by side (above) is not flattering. Instead, one leg should support the body while the other leg acts as the accent leg. It should be separate from the support leg. The role of the accent leg is to show the shape and tone of the legs and to create interest in the portrait.

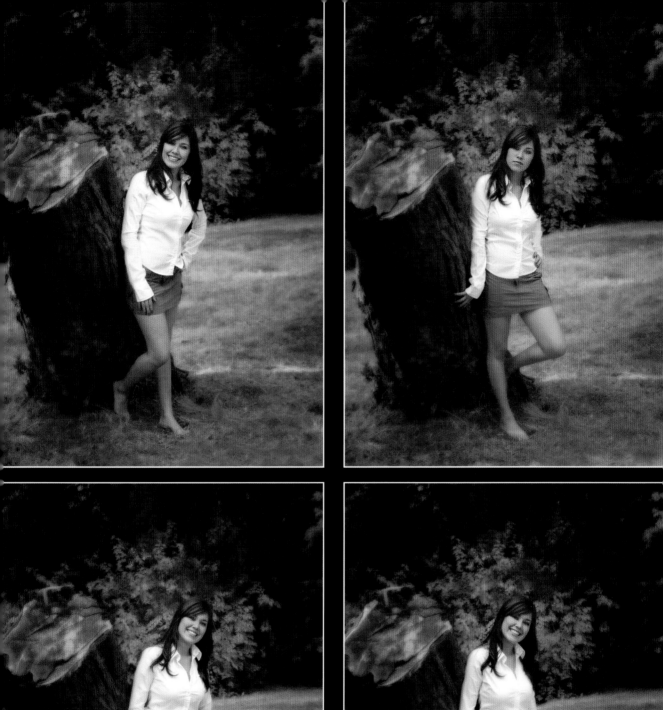
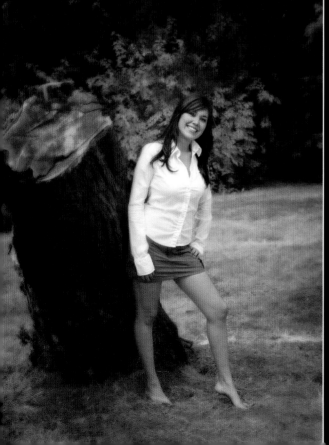
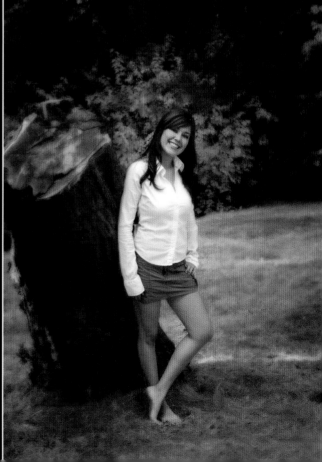

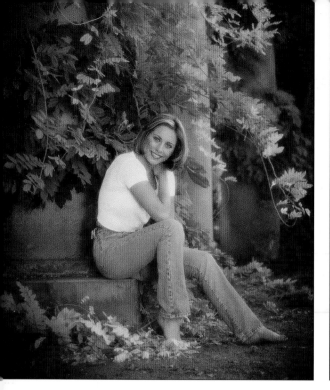 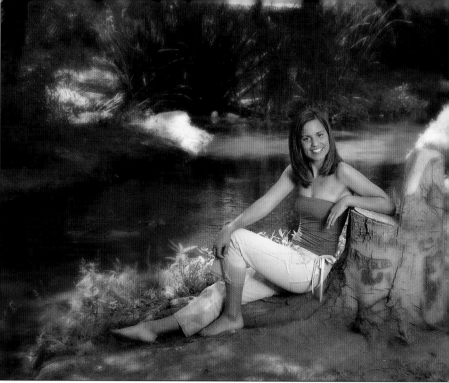

In a seated pose, one leg grounds the pose. The other is the accent leg.

with short legs sit in a chair where their feet don't touch the ground? While this is cute for little kids, a pose that is not grounded looks odd for an adult. If you have someone whose feet don't touch the ground, have them sit on the edge of the chair so at least one foot touches the ground. (Or, have both feet brought up into the chair; this grounds the pose by using the chair as the base.) The leg that is not grounded becomes the accent leg and can be "accented" by crossing it over the other, bending it to raise the knee, or folding it over the back of the head (just kidding)—but you need to do something with it to give the pose some style and finish off the composition.

The "Deadly Sins" of Leg Posing. There are literally hundreds of ways to make the legs (covered in pants or showing in a dress) look good. Again, it is easier to isolate what not to do, then move on to learning what to do. The deadly sins of posing the legs are:

1. In a standing pose, never put both feet flat on the ground in a symmetrical perspective to the body.
2. Never position the feet so close together that there is no separation between the legs/thighs.
3. Never do the same thing with each leg (with a few exceptions, like when both knees are raised side by side).
4. Never have both feet dangling; one must be grounded.
5. Never bring the accent leg so high that it touches the abdomen.
6. Don't ever expect one pose to work on everyone.

There is no one pose that will always work. Because of how flexible clients are (or are not), as well as how their bodies are designed, no single pose—no

While this is cute for little kids,

a pose that is not grounded

looks odd for an adult.

matter how simple it is—will make everyone look good. This is the golden rule of posing: when a client appears to be having a problem with a pose, scrap it. Don't struggle for five minutes trying to get it to work.

FEET

If women didn't have enough to worry about, now they have to worry about their feet. This is a relatively new area of concern about attractiveness in our society (I don't make the rules, I just respond to them).

Bare Feet. Clients don't want their feet to appear large, or their toes to look long. Also to be avoided are funky colors of toenail polish, long toenails (especially on the guys), or (if possible) poses where the bottoms of the feet show. If the bottoms of the feet are to show, make sure they are clean.

This is a relatively new area of concern about attractiveness in our society

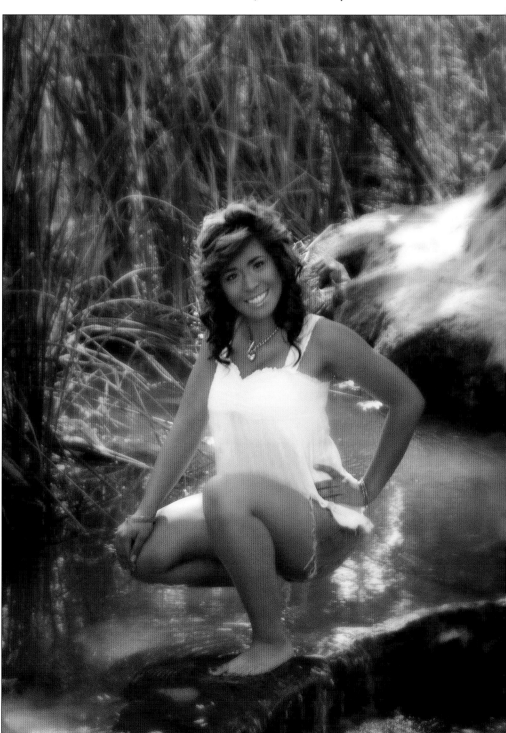

In portraits where the clothing is casual, bare feet can be a good choice.

Minimizing the Apparent Size. Bare feet can be made to look smaller by pushing up the heels of the foot. Similarly, if the feet are showing with open-style shoes, the higher the heel, the smaller the foot appears. Lifting the heels not only makes the feet look better, but also flexes the muscles in the calves of the legs, making them look more shapely. Muscle tone in the legs is determined by the muscle that runs down the outside of the upper and lower leg. Flex that muscle and the legs appear to be toned.

Posing the Toes. If a person is nervous, their toes will either stick up or curl under. Neither one is exactly attractive. Just like the fingers, toes photograph better when they are resting on a surface.

Shoe Selection. The subject's footwear should reflect the feeling of his or her outfit. If the client is in an elegant dress, then high heels should be worn. If the client is in a business suit, shoes should be worn that reflect the professional look of the clothing. As the clothing gets more casual, tennis shoes or bare feet are the best choices. Wearing socks without shoes really isn't a good idea.

Most of the time, shoe fashion really only matters with women. Men's shoes tend to fall into two categories (professional and casual), so there is little chance for mistakes. Women, however, have unlimited choices in the styles of their shoes, and usually own numerous pairs of shoes in any given style.

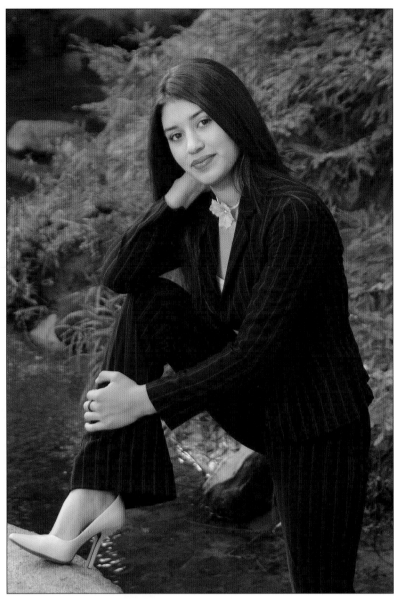

LEFT—Suits and other more formal attire require dress shoes be worn. With women, shoes with a very high heel are extremely flattering. FACING PAGE—With guys, shoes tend to be either dressy or casual, so it's not hard to make an appropriate choice.

MOVING FORWARD

In this chapter on posing the various parts of the body, we looked at how to flatter each area individually. As we continue through the chapters, we will expand on each area as it pertains to the other elements in the portrait. If you apply just these few ideas into your posing, however, your clients will look better and you will sell more portraits simply because the clients will actually like the way they look.

4. Posing on the Ground

Since the best-selling portraits are those that show the client as they really are, I thought it fitting to start out our look at techniques for posing on location with poses that have the subject on the ground. When a subject is on the ground, the overall feeling is comfort; when you pose a group of people on the ground, there is a feeling of closeness.

CLOTHING AND LOCATION SELECTION

As we've already discussed, the clothing the client wears must match the scene and the pose. In this case, we know that our pose will have a relaxed look. Therefore, the clothing and setting should have a casual feel. Jeans and

Outdoor locations and casual clothes are well suited to the relaxed look of poses on the ground.

When the subject is on her side, the weight of the body is carried by the hip bone, eliminating the mushrooming effect.

t-shirts, shorts and casual tops, and other everyday outfits will work best. Usually, the client will be barefoot. If your client wants her daughter in an elegant dress or her son in a suit, posing on the ground won't be the best choice. When it comes to the background, a park scene or garden is ideal. A more elegant location with outdoor patios or column-lined walkways isn't typically suited for this type of posing.

Please note that, in these guidelines, I am speaking in general terms for those photographers with a modest amount of experience in posing. There are *some* cases where contrasting formal clothing with a casual pose or background can be effective. If you have more experience and want to play opposing styles against each other, go for it—but make sure you are doing it to please your client, not just in a desperate attempt to be "edgy."

DISGUISE PROBLEM AREAS

When using the ground to pose, you have to remember one thing: it is hard. This hardness causes any fleshy area of the body to spread out, making the subject look larger. For this reason, you won't see me sit anyone on the ground unless something (usually their legs or some foliage) will hide the mushrooming bottom that the ground has created. Most poses on the ground have the subject laying on their side, because the bone of the hip

doesn't mushroom. Alternately, I may have the subject laying flat on their stomach, because many people with less-than-flat stomachs want full length poses taken—and, as the saying goes, out of sight, out of mind!

When creating a pose on the ground, I also look for natural obstructions to hide the problem areas that paying clients have. Tall grass, bushes, logs, wagon wheels, columns and the lower limbs of trees are amazing at making the ordinary client look extraordinary. Any of these elements can hide or soften a large bottom or hips, a not-so-flat tummy, or large arms.

CHOOSE RESTING POSES

Since the ground implies comfort, we use what I call resting posing. In this type of pose, the arms rest on the ground or the knees, and the head or chin rests on the hands or arms. In addition to looking very natural, resting poses give you a great opportunity to hide the flaws and problem areas that many clients have. When the chin rests on the hands or arms, it hides any double chin or saggy skin in this area. When the arms rest on the knees, it hides the tummy area from the view of the camera. With the body resting on one arm, the other arm can be posed to hide a problem area such as the waist.

ABOVE—Posing in areas where the grass is a little taller will help to conceal some of the body, creating a slimming effect. FACING PAGE—There are any number of obstructions that can help conceal the lower body when the subject is posed on the ground.

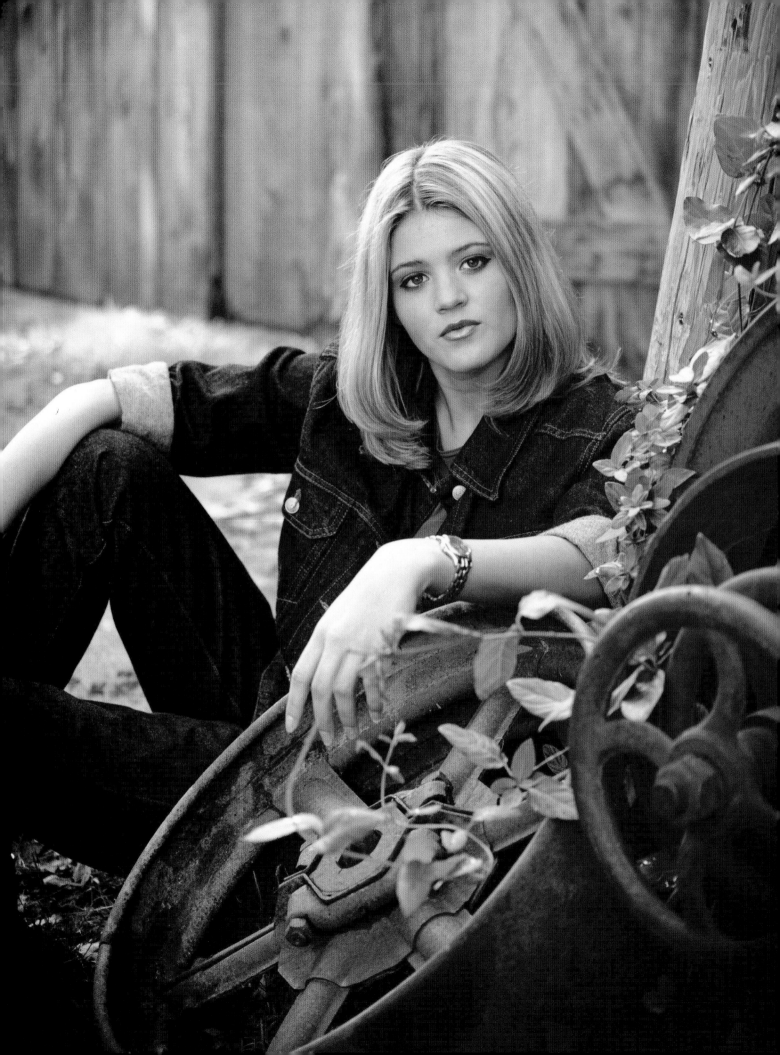

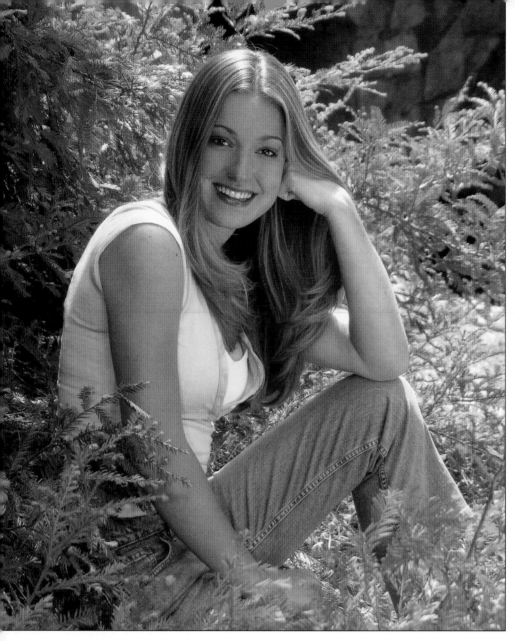

ABOVE—Poses on the ground should be resting poses. **RIGHT**—Finding a rock, log, or other posing aid in the scene can help you to create a more appealing image.

FIND POSING AIDS

When you work in the studio, you have a choice of posing aids when you want to elevate a part of the body off the ground in order to achieve a more diagonal angle in the pose. Outdoors, you need to look for a log, rock, or other natural element to use as a posing aid. With groups, you usually need to bring some posing aids with you—or at least relocate logs and small rocks to the scene where they are needed.

TECHNICAL CONSIDERATIONS

When I pose clients on the ground I typically use a longer focal-length lens and a larger aperture. This allows the ground in front of the subject to fall out of focus. I often position the camera on or near the ground to add depth in

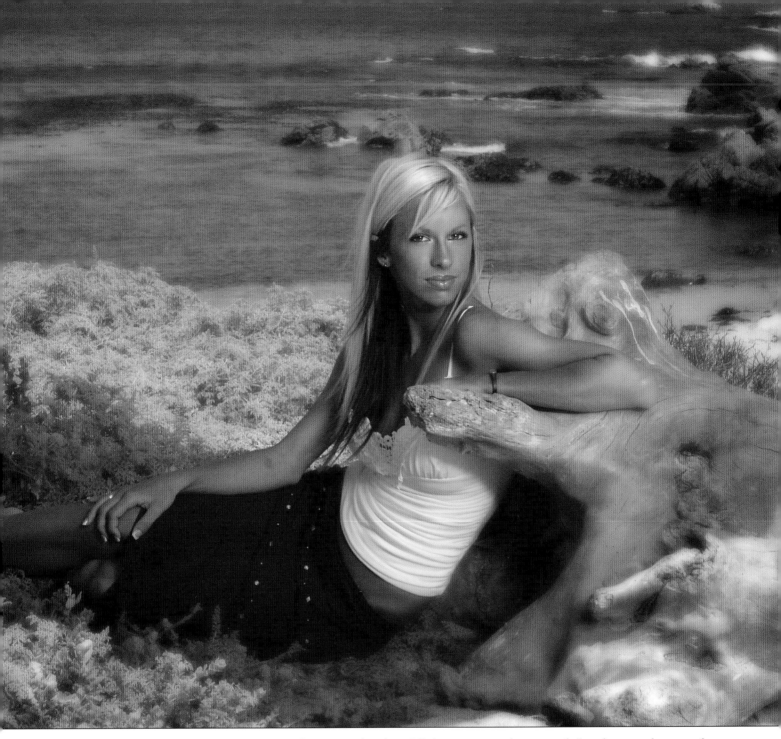

the foreground. When I light a pose on the ground, I make sure that no additive light source will brighten the ground in front of the subject. This often happens when using a soft box outdoors. Therefore, if I use a softbox, I angle it upward so the client is the first area illuminated by the flash.

PHOTOGRAPHING GROUPS

Many photographers place babies or small children in the laps of adults seated in chairs. I prefer to have the adults get down into the world of the child. When people are posed together on the ground, there is a feeling of playfulness and fun.

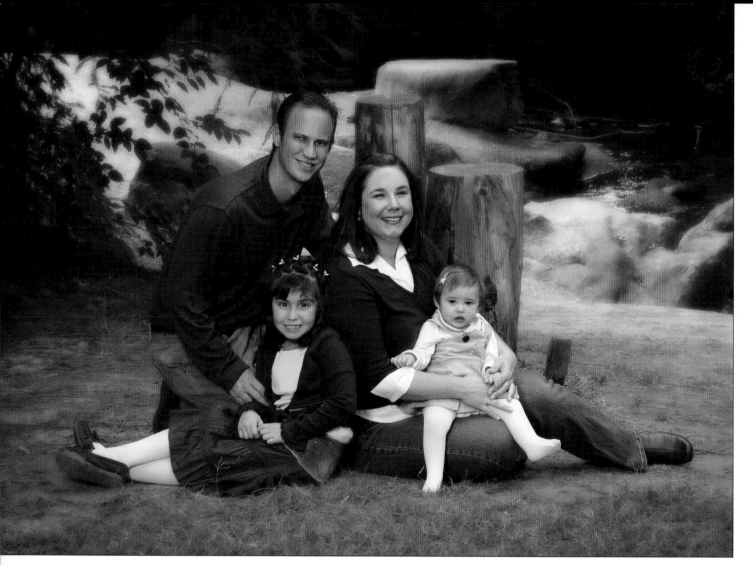

Posing a small or large group is no different than posing a single person; the poses used are the same or similar. What makes it more challenging is that each person must look good as an individual *and* the group must be well composed as a whole. Also, you have to keep the faces on the same plane to ensure they all remain in focus. Many group portraits have some of people softer than others, because the faces did not fall within the allotted depth of field.

When posing a group of people that include Mom and Dad, always place the parents in the back and children up front. The kids are usually more photogenic than the adults, so you can use them to conceal what the adults won't want to see (namely Dad's belly and Mom's hips and thighs). As always, suggest the darkest colors for those with weight issues, guiding larger clients away from the "white shirts and jeans" look if you think they might be self-conscious about their size.

As you look for a scene in which to pose people for a group portrait, look for uneven areas, slopes, or even stairs. This will make posing the faces at different heights a much easier task. We will discuss group portraits further in chapter 8.

ABOVE—Getting the kids and adults down to the same level adds an instant sense of fun and closeness to a family portrait. **FACING PAGE**—When posing groups, each subject must look good individually and the group must look good as a whole.

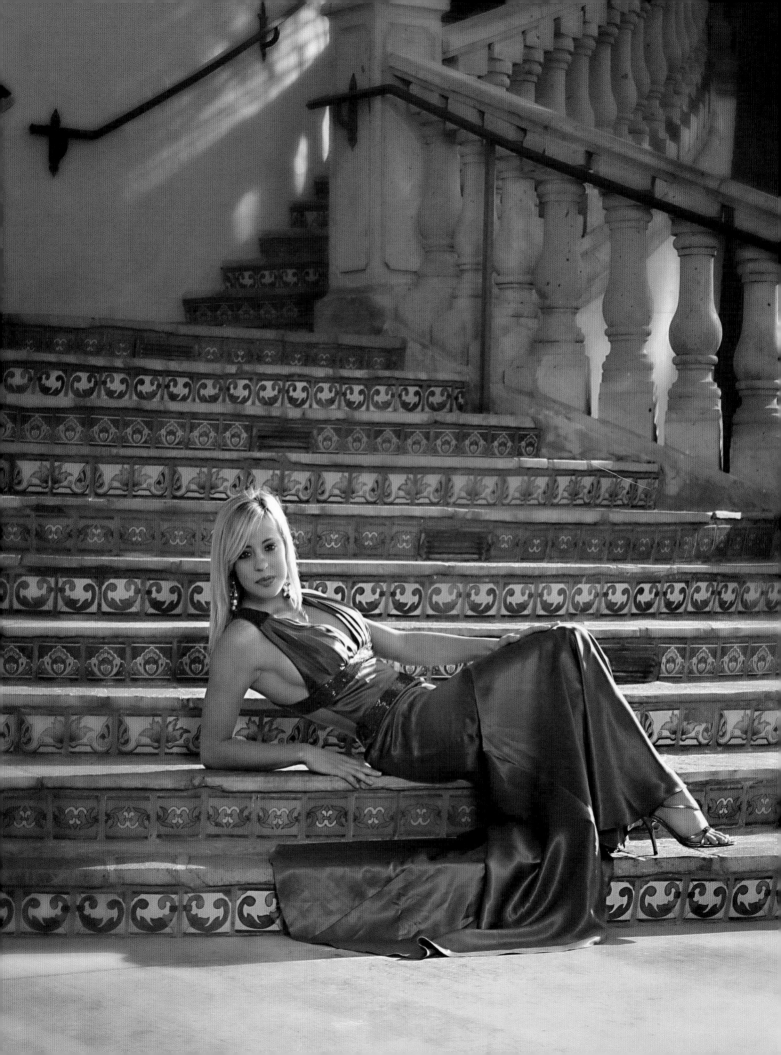

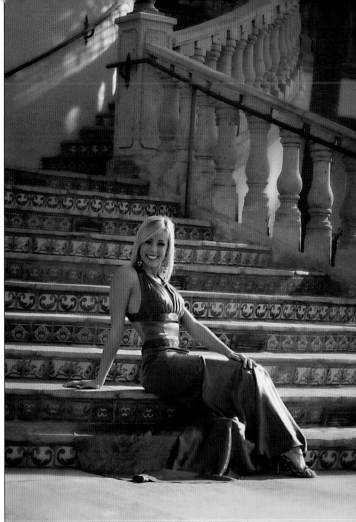

Shooting from a low camera angle often allows you to include more of the background.

ADDITIONAL TIPS

When it comes to posing on the ground, let me give you some bits of advice that will improve the outcome of your sessions. The first tidbit is to pack trash bags for the shoot—because whatever day you schedule your session for, the grass will have been watered that day. The trashbags can be used to provide a dry seat when posing on the ground. Dark brown or green ones are the easiest to hide.

Next, think carefully about camera height before you shoot. Many photographers choose a camera height based on their comfort, rather than what is best for the composition. If the client is on the ground and the photographer positions the camera at standing height, the ground becomes the background. While I do this on occasion, it typically provides a background with little depth. In many outdoor locations, this eliminates the possibility of showing much of the surroundings. It should be noted that getting down to your subject's level also helps to reduce the possibility of lens distortion.

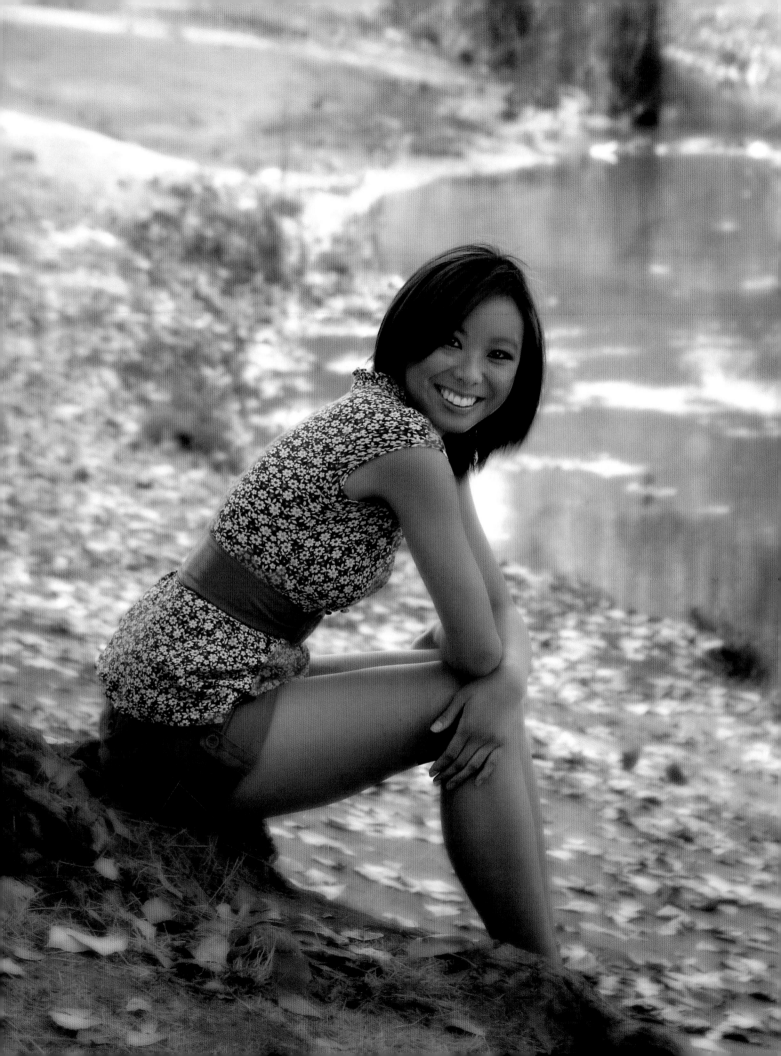

5. Seated Posing

Sitting poses appear relaxed, but not as casual as poses on the ground.

Certain clients or situations call for a pose that is still relaxed but not on the ground. The decision to get the client up off the ground may be one based on making use of a particular background, foreground, or even the lighting. It may also be because your client prefers not to be on the ground, because the ground is too wet for the client to pose comfortably, or because you need a somewhat less casual look.

Sitting poses appear relaxed, but not as casual as poses on the ground. In group portraits, they also lack the close feeling of poses on the ground. (Seated poses may, however, be used in combination with ground poses in group portraits. This can help bridge the gap between standing members and those on the ground.)

FINDING A SEAT

There are two parts to posing people sitting outdoors: first, you must know how to pose them; second, you must have something to pose them on. Finding something to pose client on can be difficult in certain locations. Some locations have very little that is at the appropriate height; other locations have

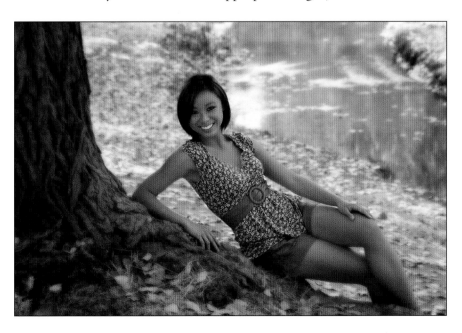

RIGHT AND FACING PAGE—Here, a large tree root provides a seat for the subject and allows for a variety of poses.

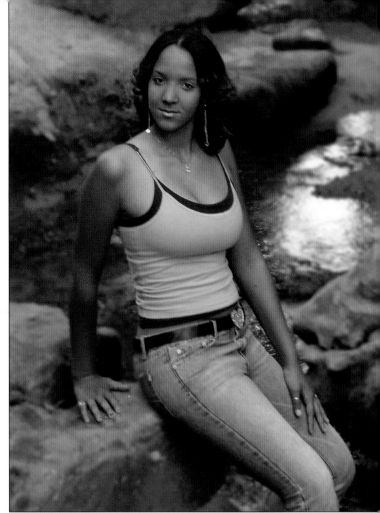

logs, rocks, fallen trees, and other man-made sitting areas. If your location doesn't provide any natural or man-made places to pose your clients, you can even bring them with you—natural-looking stools or chairs made of canes or branches, or even some light-weight fake rocks or logs can do the job. Personally, I prefer not to haul a bunch of stuff with me to outdoor shoots, so I tend to look for natural places for my clients to sit.

LEFT—Pulling the subject's arm across their waist will help cover this area in seated poses. **RIGHT**—Having the subject sit up very straight helps smooth the stomach area in seated poses.

COMMON PROBLEM AREAS

Hips and Thighs. Once you find a seating area, there are two important rules that you must always remember. Before I tell you, though, I want to show you the first one.

I want you to put this book down. If you are sitting, stand up. Now, sit back down and watch your thighs and hips (if you're wearing a skirt or dress, you may have to tuck the material tightly around your legs to see this). If you are being honest, your legs and hips will grow in width anywhere between 25 and 60 percent depending on your muscle tone. I don't care how much time you spend in the gym, you *will* widen out. So that's our first rule: never sit someone down flat on their bottom.

While you are still seated, roll over onto your hip—the one that would be closer to the camera. Notice how much slimmer your legs appear? Your bot-

I prefer not to haul a bunch of

stuff to outdoor shoots, so I tend

to look for natural seating.

tom is now behind you, so it doesn't mushroom out widening the hips. So that's our second rule: pose your clients on their hip closest to the camera or make sure that this area will be blocked from the view of the camera.

Waistline. One last thing, look at your waistline. I don't care how many situps you do every morning—in a seated pose, your waistband or belt will cut in and cause a "belly" to form over the top of it. The only cure for this problem is to hide the area from view. If that is impossible, have the client sit up as straight as possible to stretch out and flatten the stomach area, minimizing the problem.

GROUND THE POSE

The second rule of sitting a client deals with the feet and legs. Never have a client sit without being able to touch the ground. A foot must be grounded.

In a seated pose, your waistband or belt will cut in and cause a "belly" to form over the top of it.

In a seated pose, the subject should have at least one foot on the ground.

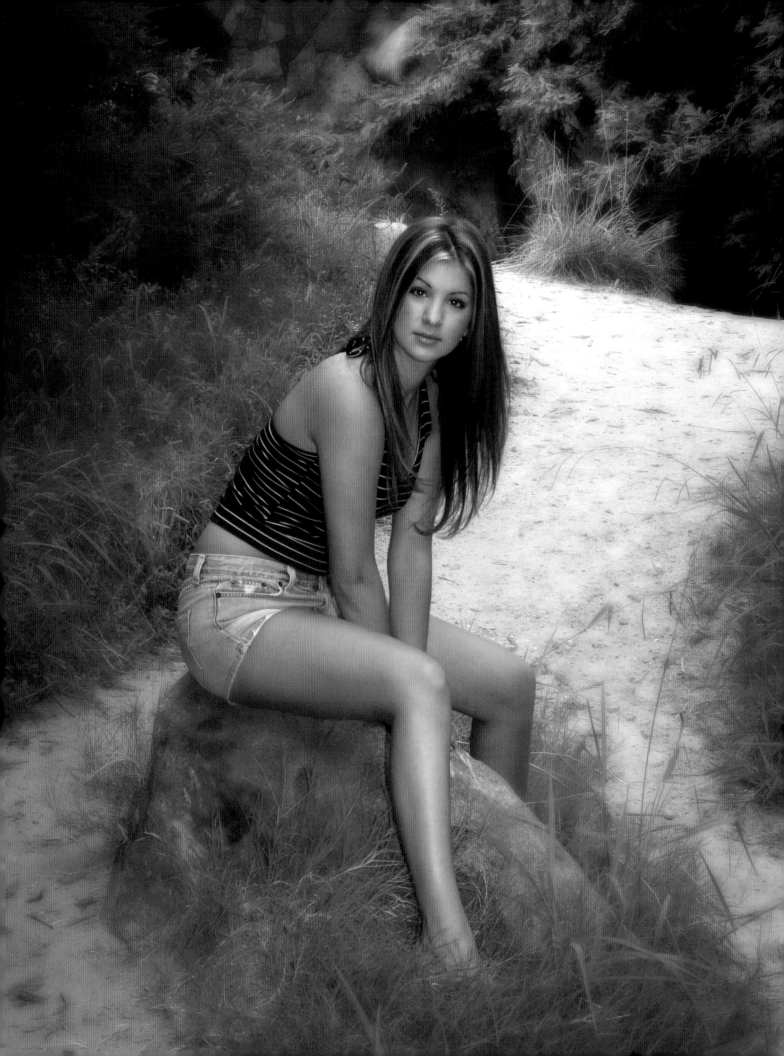

FACING PAGE—Here, the subject is leaning forward and posed at an angle to the camera. ABOVE—Finding natural posing aids isn't always easy—and when you do find them, they usually aren't at the correct height. In this pose, we had the young lady do the splits to lower herself to the level of the cut off stump.

Once you have a foot that is grounded, the other foot/leg becomes the accent leg. You can cross the leg over the grounded leg, you can bring the leg back and push up the heel of the foot, whatever you want to do, but always have one foot on the ground and the accent leg in a position that adds interest to the pose and subject.

ANGLE THE BODY AND LEAN FORWARD

As in most poses, seated poses should have the subject's body turned to the side of the frame. Unless you are pulling the legs in close to the body to rest the arms on top of them, the knees should never be pointing directly back at the camera.

Looking at outdoor portraits taken by other photographers, I often notice that they have the subject reclining back into a chair or sitting straight up on a rock or log. In contrast, I prefer to have the subject leaning forward to rest on their knees; this automatically covers the waistline, which becomes such a problem in seated poses. I also think it looks much more natural. If you have ever sat on a rock or log, you know that you tend to make yourself more comfortable by leaning forward on your knees.

In group portraits, having the seated subjects lean forward onto their knees also lowers their faces to get them closer to any subjects who might be posed on the ground. When we are photographing a couple, we often pose

Here, both subjects are seated, but at different levels. Still, the subject on the taller seat leans forward to bring her face closer to the face of the subject who is posed on the lower seat.

the man in a seated pose leaning forward, while the woman is posed on the ground between the legs. We have the man lean onto his one knee and then angle the woman slightly toward the other knee so the faces are closer to side by side, instead of one over the other.

ARMS

When you start to refine the pose, make sure the arms are not resting heavily on the body but separated from it to define the shape of both the arms and the body. This can be done by placing one hand on prop or posing aid, or simply by extending one arm to rest the hand on the knee and letting the other hand rest on the thigh. Again, remember that the hands and arms can also be used to conceal any problem areas your client might have.

Remember that the hands and arms can also be used to conceal any problem areas.

COMPOSITIONAL OPTIONS

Although seated poses and poses on the ground are somewhat challenging, they offer many compositional options. You can go from head-and-shoulders images, to waist-up shots, three-quarter-length portraits, and then full-length images without ever having to re-pose the client. As you can imagine, this helps speed up the session—and the faster you work, the more profit potential each session has.

As you look through the seated poses in this chapter, don't just try to memorize the pose. Ask yourself why. Why were the hands and arms placed where they were? Did they cover a problem area to enhance the subject's appearance? Look at the foliage, grass, and tree limbs. Why are they there? Are they hiding something or just adding to the appearance of the image? Getting into the habit of asking these questions when you look at images will help you to ask them of yourself when you are photographing your clients.

In many seated poses, you can create a variety of looks without having to adjust the subject. This head-and-shoulders portrait was created with the client posed for a full-length seated image.

6. Standing Poses

The full-length standing pose can be striking *if* you have the ideal situation—the right client, in the right clothing and shoes, in the right scene. As we will see, though, there are a number of potential problems. For that reason, you and your clients may prefer to do three-quarter-length or waist-up portraits when photographing standing poses.

FULL-LENGTH STANDING POSES

Unfortunately, the decision to do full-length portraits is more often made by photographers who want impressive images to hang in their lobbies than by clients who intend to buy this style of image. There are exceptions, of course. Sometimes, a client wants to include a car, house, the ocean, or another larger vista in their image. In this case, a standing full-length composition is likely the best way to accomplish their goal. In a situation like this, your objective should be to take up as much of the frame as possible with the subject. This ensures that they don't get lost in the scene. It also helps address the fact that clients want to see the subject's face above all else.

Potential Problems. The standing, full-length pose has two major problems. First, there is no way to hide the major problems that most clients have (weight issues, etc.). Second, this type of pose greatly reduces the facial size, and that can result in fewer sales. I always tell my clients that if there is a *reason* to take this type of pose (for example, they want to show their dress and can't sit in it, or they want to show off their long legs), then we will do it. If there isn't a good reason, we will pose them in seated or laying poses. This allows us to achieve a full-length image while keeping our options open when it comes to managing problem areas.

If weight is at all a concern, gently explain to your client the other styles of posing would be more flattering. This is one time when it is particularly hard for many male photographers to understand why female clients want to do poses and select clothing they obviously should not.

If you are a man over forty, think back to the first photo you had taken after the aging process started working against you. I have seen grown, mid-

In this case, a standing full-length composition is likely the best way to accomplish their goal.

Some situations dictate a full-length image. Here, the subject is slim, the background is beautiful, the dress has a unique hemline that looks best when standing, and the subject is wearing high heels. All the ingredients are in place for a successful standing full-length pose!

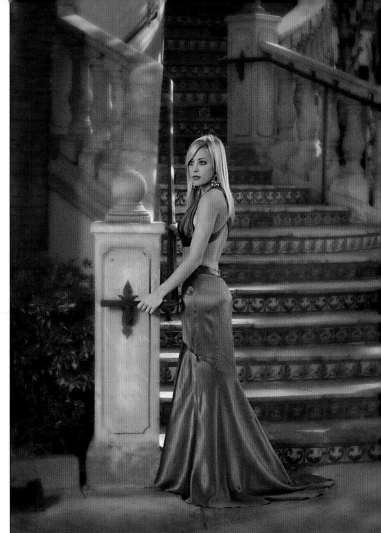

A great location, a beautiful dress, and a slim client all contribute to the success of these full-length poses. Softening the background helped keep the emphasis on the subject.

dle-aged men completely shocked by the fact they were bald. They had convinced themselves that those three strands of hair twirled around their head really had everything covered! The same sort of wishful thinking goes on in everyone's head. We "overlook" the effects age and weight gain because they happen slowly over time. Before you know it, though, you don't recognize the fat, bald guy in the photo.

This is why we must try to understand it when a young lady with heavy arms, a less-than-flat stomach, and thick ankles wants to wear a short, sleeveless dress with flat shoes. As a professional, you have to recognize that there is no way this woman would be happy with her appearance given these circumstances. Then, you have to come up with a plan for achieving the look she wants—while saving her ego from having to look at the harsh reality.

THREE-QUARTER-LENGTH STANDING POSES

In many cases, a good compromise is to create a three-quarter-length standing pose. This is often enough to show off the subject's outfit and the background, while still maintaining a larger face size in the frame. Best of all, you can shoot this variation without having to adjust the subject's position. Just pose the subject for the full-length image (following all the guidelines we'll

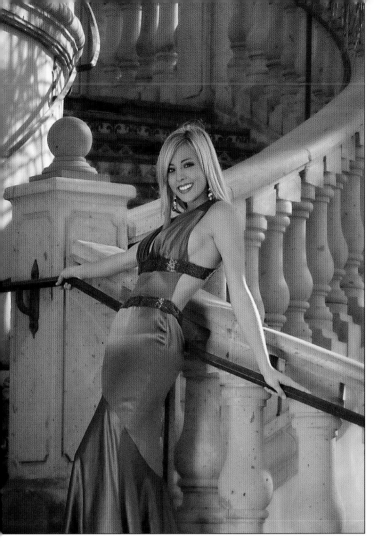

Here we see the same subject in the same location, but we've moved in for a series of three-quarter-length portraits. These give the client an option for an image that still shows the location and gown, but also shows a larger view of the subject's face.

look at below), then zoom in or adjust your camera position to create the tighter image. You may also be able to create a waist-up shot and a head-and-shoulders portrait in the same pose.

DETERMINING THE POSING STYLE

As in the other poses we have looked at so far, the clothing and the location will help you to determine the style of posing that would be best for your image. If the young lady is in a jean skirt at a park location, you would use a different pose than if she was in a glamorous gown at a location with beautiful architecture.

More relaxed clothing and a casual scene would suggest a more relaxed pose. A relaxed look in a standing pose is typically achieved by having the subject rest on or lean against something. This can be a tree, column, building, bridge, wagon wheel, log or anything else that is at the appropriate height and substantial enough not to shift with the subject leaning against it.

More dressy clothing and a refined scene would suggest a more formal pose. A formal look in a standing pose is typified by grace and elegance. No part of the body is bent excessively. The posture is typically upright; people in formal poses don't lean against anything. The hands rest gently on the

body or on some element of the scene. The support leg is straight and the accent leg is less dramatically posed than it might be in other styles.

ADDITIONAL CLOTHING CONCERNS

I have two additional clothing suggestions. First, make sure that it fits properly. Clothing that is too baggy will add weight/width to the client, and this is only good if you have thinner guy who wants to look bulkier. Conversely, too-tight clothing will show every bulge and line. Proper fit is especially important in standing full- and three-quarter-length portraits, since more of the clothing will show and there's less you can do to disguise problems.

A second area of concern is the contrast (or lack of contrast) between the subject's clothing and the background. This is a major factor in posing when the subject is standing, and especially in full-length portraits. Ideally, you want the areas of the body that show weight-related issues to blend into the background while important areas, such as the face, legs, and cleavage (if showing), contrast with the background. This will draw the eye to only these places.

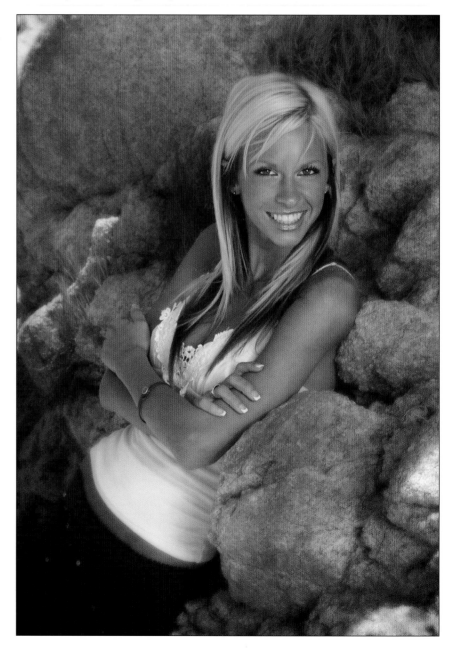

In this image, the subject's contrasting outfit is matched by the tones the appear in the background.

The idea here is to coordinate the background to the clothing and hold the viewer's eyes where you and your client want it. For example, let's imagine you are designing a portrait from the ground up with a client who will do exactly what you ask. The client has a fair complexion wants a full-length portrait that focuses on her long legs. What would you do? Ideally, you would put the client in darker tones, but have her wear a short skirt with high heels. Then, you would select a scene that is dark enough to give separation to the subject's skin tone without contrasting with the dark clothing. If you did this, the eye of the viewer would be drawn to every area of skin. With a long-sleeved top, the only areas of skin visible would be the face and her long legs.

Now, this is in a perfect world where a client listens to what you say. In the

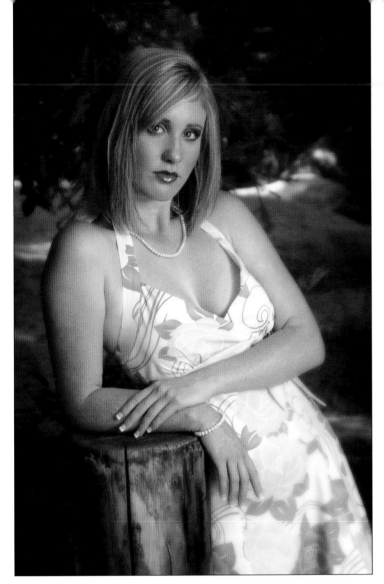
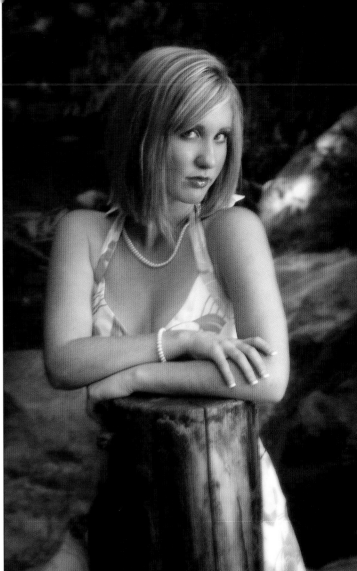

Here, a casual scene and summer dress coordinate nicely with the casual leaning poses.

real world that we work in, this rarely happens. Realistically, the client will show up with one outfit—a white top, a black skirt, and flat shoes. To deal with the contrasting clothing, you would simply look for (or create) a scene with a lighter tone behind the lighter areas of clothing and darker tones behind the darker tones of clothing. Many photographers are thinking, "You have got to be kidding!" No, I am not. Do you remember when we talked about creating images that have a sense of style? I said that the photographer is responsible for *everything* you see and don't see in the image.

Very few times are you actually going to find a scene that has lighter and darker areas in the correct places. Therefore, you must add light to the areas you want to make lighter or use the camera elevation and angle to put to proper tones of backgrounds with the coordinating tones of clothing. This isn't just a technique to be used for a young lady who wants to show off her legs. The same idea can be used for a young lady who wants to hide her hips, a mother and father who don't want to see their actual body size in a family photo, or in any other situation where you want to control the eyes of the viewer.

POSING

Shoulders at an Angle. When the body rests on an element in the scene, one shoulder is typically lower than the other. This gives a relaxed appearance and is best suited for more casual portraits and settings. When you want to use elements of a more elegant scene as posing aids, you should prevent the body from leaning or resting on them. Instead, the hands or arms should gracefully and gently touch the column, tree, etc.

Arms. As noted previously, the subject's arms should be separated from her torso to define her waistline. Having the subject do something with the arms (other than letting them hang at her side) can also make the image a lot more interesting, as shown in the examples below.

Hips and Legs. While the basic structure of the standing pose from the waist up varies depending on the location and the clothing style, the rest of the posing is very similar in design. We begin by turning the subject toward the shadow side of the frame.

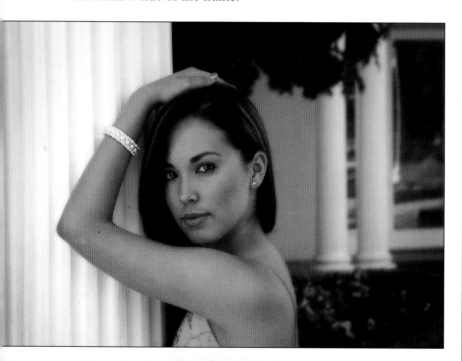

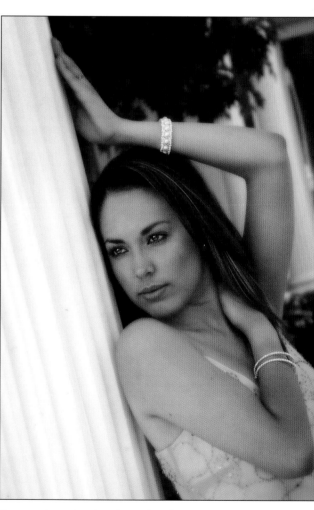

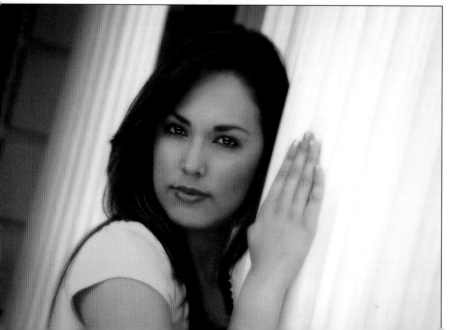

There are lots of options for posing the arms in a standing pose. Note that, in this example, the portraits have been posed as standing, full-length images, but are composed much more tightly.

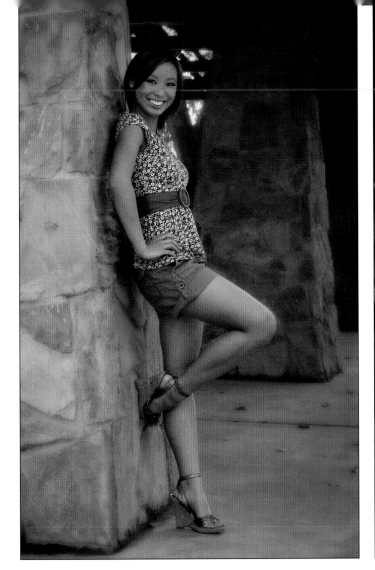

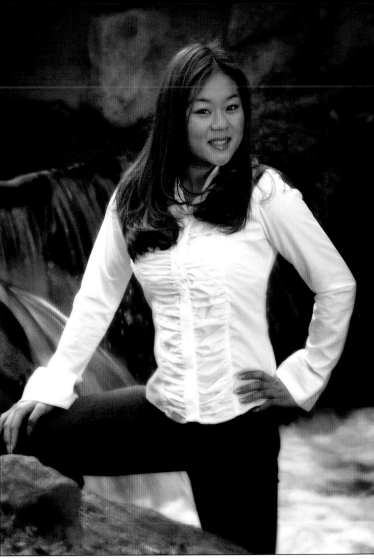

LEFT—In standing poses, one leg is the support leg, while the other leg is the accent leg. The accent leg is bent and often shown from the side to reveal its shape. **RIGHT**—In a stepping pose, the raised accent leg creates a good base for the portrait.

The thighs are not directly next to each other (or posed identically) and one leg supports the body while the second leg is the accent leg. The feet are in high heels, or at least the accent leg has the heel pushed up to flex the leg muscles and make the feet appear smaller. The accent leg could be crossed over the support leg, extended out, or placed to form what I call a stepping pose. The pose is just what the name implies: you have the subject step into a typical position to rest their foot on some element in the scene. This gives the body a forward angle, creating a diagonal through the frame. Stepping poses look very natural because they provide a good base for the upper body.

CORRECTIVE TECHNIQUES

Although standing poses (especially full-length ones) are designed to show off the body, you can still use elements in the foreground to hide or soften problem areas. When necessary, I will use the "peek-a-boo" pose, placing the majority of the body behind an obstruction and just letting a portion of the shoulder, the side of the body, and one leg show in the photo. While this posing isn't ideal, it is a way to provide a standing full-length pose for a determined client—a way to give them an image that their ego can handle.

7. Head-and-Shoulders Poses

While photographers get excited about full-length poses, clients get excited about images that are composed closer or in a head-and-shoulders style. As many as seventy percent of all portraits ordered are composed from the waist up, yet most photographers focus their attention on full-length shots, especially if the guy or girl is nice looking and fit. The hype about full-length poses is the strongest in the senior market, where many photographers look at full-length poses as the way to separate themselves from the contracted studios, which mostly take boring head-and-shoulders poses. The problem is that they focus so much attention on

Don't get so caught up in the excitement about full-length images that you forget what actually sells portraits: the face.

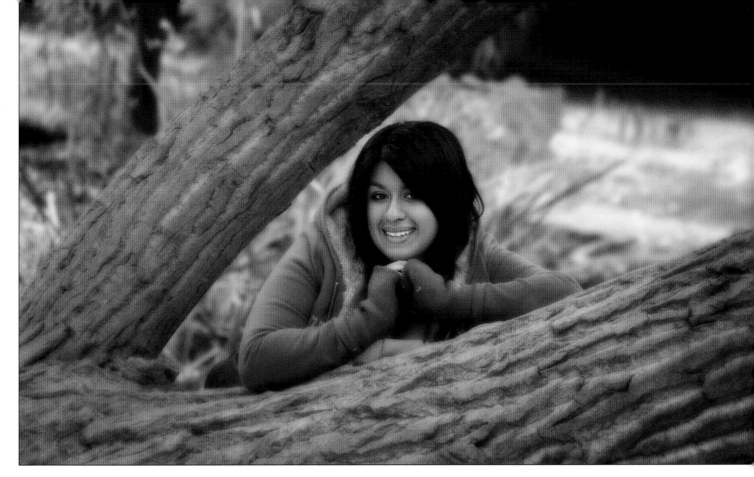

In this image (and the one on the facing page), the scene and posing were chosen to conceal or soften the areas that I know any woman would worry about.

full-length images that they forget about the part of the session that generates almost three-quarters of their sales.

CLIENT EXPECTATIONS

While creativity in head-and-shoulders poses is vital to the success of your business, there are times when creativity takes a back seat to the client's expectations. If you are taking a portrait of a woman running for city council, the classic, boring, head-and-shoulders shot might be what is wanted; it is what's expected. Again, the end use for the portrait must dictate all the choices you make in the portrait's creation.

We have each senior select their poses from over five hundred samples we have collected into small albums. Usually, the senior selects nothing but full-length portraits and extreme close ups; these are the images that are most like what they see in the media and in magazine ads. The mother, trying to be a trend-setting modern woman, says, "It's okay. They're *her* senior portraits." Of course, she only *stays* a trend-setter until she sees the previews—that's when she realizes that her daughter's choices have left her with no portraits that are suitable to give to her friends and family.

To solve this issue, we photograph in the full-length pose they have selected, then we take a head-and-shoulders pose using the same background and pose. This way the senior has her full length that shows her shoes and outfit and the mom has the images that the majority of sales come from.

INCLUDE THE FOREGROUND

The one problem with outdoor sessions taken in a head-and-shoulders style is that clients like to see the depth and beauty in the background, but they also want to have the facial size. To overcome this problem, I changed the way in which I pose my head-and-shoulders portraits. I used to put the subject under a tree with the limbs or other close-by foliage as the background. This gave me a portraits that I could easily re-create in the studio with green screen and an old stump. Now, I look for areas that offer foreground elements branches, grasses, etc.) to hide or soften the areas of the body that might be a problem to the client in the final pose. This also helps provide the sense of depth that clients want to see in their outdoor portraits.

When using foreground elements, I suggest that you don't pose your client *in front of* the background. In stead, pose them *in* the background. Most photographers place their client in a clearing with a background that features numerous elements at many levels and distances from the subject. To create a foreground, you simply put the subject in the middle of what was to be the background. You still have the same depth, because you are using elements in front of the subject as well as behind, however you now have the ability to hide portions of the client from view.

CLOTHING SELECTION

One word of caution about head-and-shoulder poses: avoid strapless dresses or tops. You and I might understand that even though you can't see the clothing the client had on, she definitely wasn't naked. To others, however, this is less obvious. Fathers often bring this to my attention if I take a tight head-and-shoulders pose in a strapless dress that just shows the bare shoulders and no clothing below. It makes me glad I have sons!

POSING GUIDELINES

Shoulders at an Angle. In a head-and-shoulders pose, the shoulders should never go straight through the frame, with the left shoulder being at the same height as the right one. To ensure this isn't a problem, have the subject lean slightly to the side.

Body and Face at an Angle. Equally, you should never have the body squared off to the camera. Always

The background is a big concern in outdoor portraits. By carefully choosing the position of your subject and camera, you can often improve your results. In the top image, the background has both very light and very dark areas. Moving to the right (middle) did not produce an acceptable background either. In the final image (bottom) repositioning the camera so that the background was filled with dark foliage produced a better image.

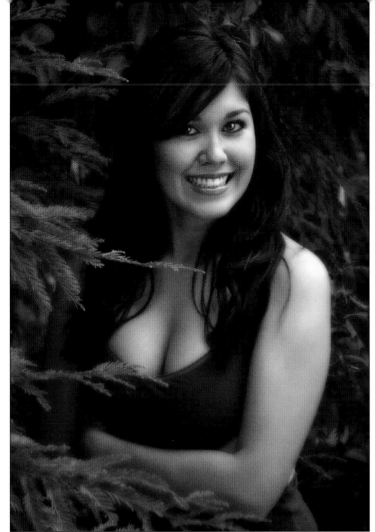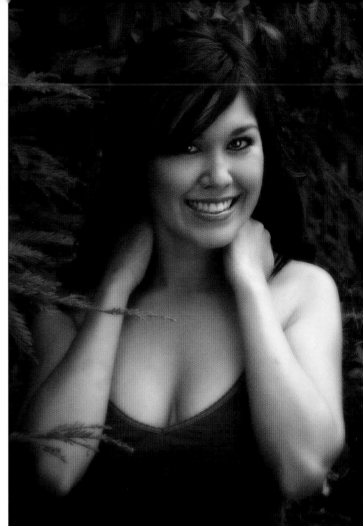

In a head-and-shoulders portrait, the arms should be used to frame the face and create a base for the composition.

pose the body facing the shadow side of the frame and turn the face back toward the main light. The size of the face in a head-and-shoulders pose is larger than in other images, so the position of the eyes is very important, and this will typically make the eyes appear larger.

Arms and Hands. In images that are composed closer, arms and/or hands need to be closer to the face. This not only adds interest, it also helps hide problem areas like double chins. Additionally, it provides a base to the composition.

A good place to start is with the traditional head-and-shoulders pose, with the arms brought up by placing the hands on the hips. This provides a very classic look, as long as the shoulders are at an angle. Next, have the client cross their arms. While there is very little difference in the pose, the look and feel is completely different. Essentially, you are looking for ways to frame the face—so experiment with some variations and see what works for you and your clients.

Extreme Close-Ups. Classic head-and-shoulders images have always been good sellers, but extreme close-ups are also really popular—especially with the degree of retouching now possible with digital capture. To increase the number of interesting poses you offer, subscribe to fashion magazines and tear

out the ads and pages that have interesting head-and-shoulders images. These images are what set the standard for beauty in your clients' eyes.

Include the Body. You may be wondering why I've talked so much about hiding figure flaws in a chapter that is supposed to be about head-and-shoulders portraits. It's because of another change I made in the way I posed many of my head-and-shoulders poses in order to make them more marketable. Like most photographers, I thought of a head-and-shoulders pose as a standing pose with the arms folded or leaning on a tree. Then, I realized that I could also create a head-and-shoulders image by posing the subject laying down on their stomach with their face closer to the camera and their body behind them at an angle.

We sell *lots* of these poses, because they have the larger facial size the parents like and show most (if not all) of the body, which the senior likes. They also allow us to show more of the scene, which works really well for outdoor sessions. I like to have the subject lay on their stomach with their faces closer to the camera. The body is placed diagonally behind the head so the side of the hips and legs shows as the body extends into the background. Combine this style of posing with scenes that have a greater depth and you will create portraits that show the beautiful surroundings while satisfying both the older and younger buyers.

Expression. With the larger facial size, you should always have the client look at you as you direct them through the expressions you want them to

When using a posing aid in your head-and-shoulders portraits, you should never let any weight rest on the fleshy parts of the forearms or biceps.

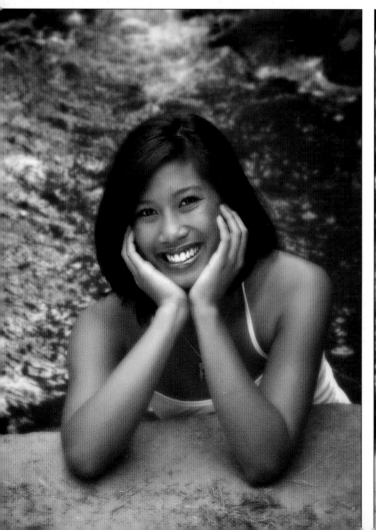
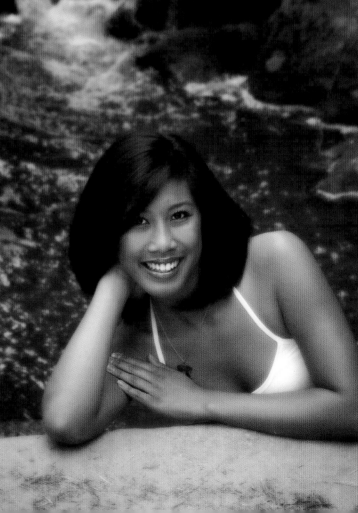

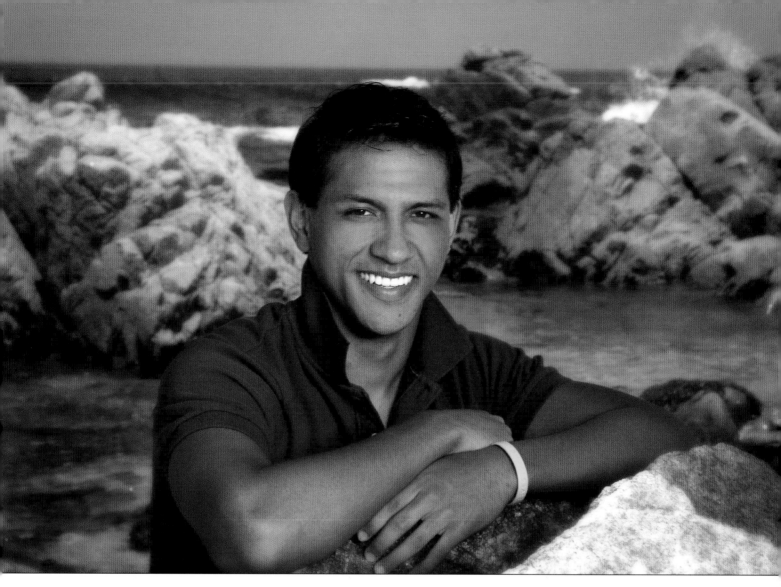

Having a great expression is critical in a head-and-shoulders portrait.

have. A subject looking at *someone* rather than *something* will have much more life in their eyes. When I was younger, I used to think this was a little silly, but then I started comparing poses that were taken while I used a tripod and had the client look at me against those I create while handholding the camera and having the subject look into the lens. To my surprise, there was a huge difference in the eyes. In head-and-shoulders portraits, the eyes are critical, so enlivening them in this way is particularly vital.

COMPOSITION

In most head-and-shoulders portraits, the arms and/or shoulders help form the base of the composition, basically filling in the lower portion of the frame from side to side. When you turn the subject so far that the body doesn't fill the lower portion of the frame, the base of the image is missing and looks incomplete. This is true for every portrait from a head-and-shoulders to an image composed from the waist up.

Many young photographers have issues with trying to find the point at which to crop the image at the bottom of the frame. The answer, typically, is

to crop the image at the widest part of the base, whether this is the shoulders or (in a pose with the arms on the hips) the elbows. This fills the bottom of the frame and gives a complete base for the composition.

LIGHTING

In a pose with a larger facial size, the lighting must be flawless. The eyes must have beautiful catchlights, and the mask of the face must be perfectly lit. This requires you to be able to see and control the light in the scene. If you have read any of my other books, you know that I will only use flash for full-length poses (and then I use studio flash, never on-camera flash). No matter how good at lighting you are, you can never really see the exact effect of the studio lighting until you print it out or magnify the image on a computer monitor. Therefore, when creating head-and-shoulders poses, I always use the natural light and modify it with reflectors, black scrims, translucent panels, and/or mirrors. This lets me see the exact effect I am producing.

The eyes must have beautiful catchlights, and the mask of the face must be perfectly lit.

8. Group Portraits

Many photographers have a difficult time learning how to pose group portraits. The challenge, of course, is that you must apply all of the techniques used to pose a single person—but on multiple subjects and simultaneously. Additionally, you must ensure that the assembled group, as a whole, looks both cohesive and appealing. A final consideration is that the portrait must reflect the relationship between the subjects—whether they are business partners, members of a family, or school friends.

A couple is the smallest and simplest group to photograph.

DETERMINE WHO WILL BE IN THE PORTRAIT

The first question when posing a single person is the end use for the portrait. The first question to ask when photographing a group session is who will be in the portrait. If your session invoice simply states that there will be two people meeting you at the park, you don't have much to go on. They could be an older couple, folks who might have a hard time getting into poses on location. They could be sisters, in which case you would want to show the closeness between them—but that would be a different kind of closeness than you'd want in a portrait of a young couple in love. It would also be different than if you were photographing a mother and baby. The individuals in the portrait and their relationship will determine how you pose them and at what height or position (standing, sitting, or on the ground).

CLOTHING SELECTION

The coordination of color and tone between the subject and the scene, as well as between the peo-

ple within the group, increases in importance with the number of people in the group. It is possible to create an appealing portrait with two people wearing contrasting tones or colors, but it is impossible to do this with a group of ten or twelve people. With the reduced facial size, the viewer's eyes will be drawn to the contrasts in clothing tones or colors, and not to the subjects' faces.

It is best to talk with the principal female in the group and explain how important color and tone coordination is. Typically, they will help make sure everyone dresses similarly, and often buy matching clothing for the group. While color and tone are important, so is the style of the clothing. You can't have everyone in sweaters and one person in a t-shirt or shirt and tie. The style needs to be similar and should be coordinated to the style of scene, pairing casual styles of clothing with typical outdoor scenes and dressier clothing with more formal locations.

The one time that contrasting clothing is appropriate is when very small children or babies are to be photographed with full-grown people. In this case, having them dressed in contrasting color or tones helps draw the viewer's eyes to these very small people in a very large world. Without con-

Clothing selection is important. In this image, all but one subject wore green. The mismatched shirt had to be retouched to create the image seen here. Remember to advise your clients that ignoring your advice about clothing suggestions may result in additional retouching fees.

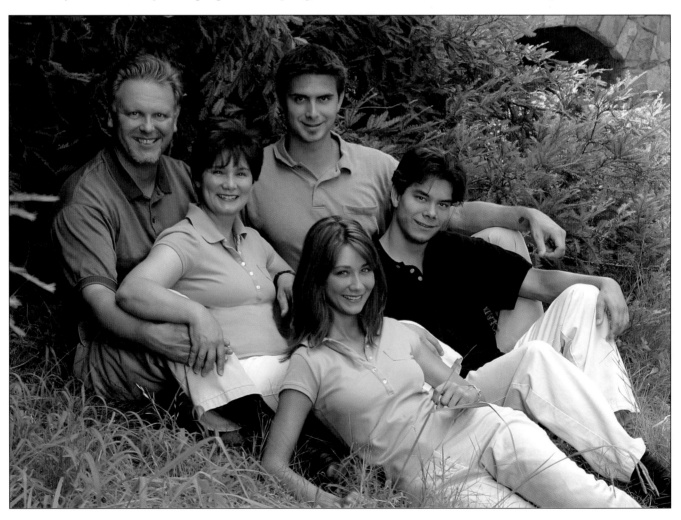

LEFT (TOP AND BOTTOM)—Here, the two girls are posed for a three-quarter-length portrait. **RIGHT (TOP AND BOTTOM)**—Creating a head-and-shoulders image of the same subjects requires more than just zooming in. The young ladies had to be re-posed in order to bring their heads closer together.

trasting colors or tones, the family members (especially the mothers) often feel like the babies are lost in the overall grouping.

POSING

Before planning the poses for the group, you need to decide how the portrait will be composed. Will it be a waist-up shot? A head-and-shoulders? A full-

length? In a portrait of a single person you can easily go from a head-and-shoulders to a full-length image without changing the pose; you just change the focal length of the lens. This isn't usually possible with larger numbers of people, so you'll need to have your goal in mind before you start arranging the group.

Choose a Basic Structure. I see many group photos that look more like a mob of people waiting for tickets to go on sale than a close, loving family. To combat this, you need to start with some kind of structure while building your compositions for groups. You can then modify the structure once the basic composition has been achieved. This is much better than having no composition at all.

A basic pyramid composition, with the tallest person in the center and the heads gently sloping down to either side, is a simple starting place for groups. To modify that basic structure and achieve a more interesting look, break the straight line of the downward angles by posing some of the heads below or above the distinct downward lines of the pyramid. This gives the composition the basic pyramid structure without the "old school" look.

If I am going for structure with a linear composition, I actually like using diagonal compositions more than pyramids. In these compositions, the heads

Before planning the poses for the group, you need to decide how the portrait will be composed

The pyramid form is a simple way of arranging a small group in a classic portrait.

LEFT—In this pose, there is a slight diagonal created by the natural heights of the subjects. ABOVE—Here is a more interesting variation. Mom and Dad are in the center, flanked by their sons. From left to right, the pose has three faces in a downward-sloping diagonal line. The last face, however, is brought back up almost to the level of the face on the far left. This creates a mirrored effect that is very engaging.

are arranged so that they create a line that slopes across the frame. This is very effective in small groups like sisters, brothers, or small families.

Ground the Pose. I like to see groups with at least some of the members on or near the ground. This softens the look of a more traditional portrait and doesn't give the stuffy and stiff look of everyone standing in a basic pyramid. Even when the clothing and setting are more elegant, I generally don't like to see everyone standing in order of height or on stairs. I want to break up the straight line with people in seated poses to lower their heads.

My favorite way to arrange a group is to start out on the ground and build the composition up person by person. This gives me the creative freedom to pose each person effectively as an individual, but also to come up with interesting compositions that don't follow the pyramid lines.

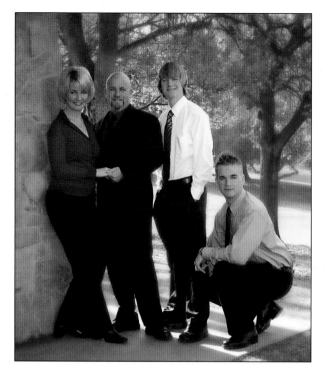
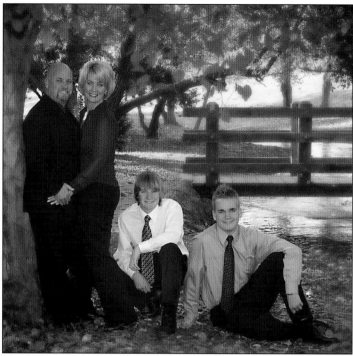

Getting at least one member of the family down to ground level helps make the image look more relaxed.

Head Height and Proximity. The correct facial height and proximity depends on the number of people in the group and how large of an area you want to use for a background.

When posing a couple or small group, if I decide to compose the portrait closer up (showing from the waist up for each member of the group), I position the eyes of one person at about the mouth level of the next person as I am building the composition. With larger groups, it is often impossible to put each face at a different level. Instead, you will simply create some basic posing structures (lines, pyramids, etc.) with some modifications and variations here and there to add some style.

In a typical portrait of a couple or group, the subjects are touching—usually with their bodies overlapping a bit. If, however, a family group wants to show their home, horses, cars, tractor, or the ocean in the background, you may need to have several feet between each family member to create an effective composition. Whether the individuals are closely packed or spread out, however, the key is that they should all be approximately the same distance from each other. If one person is visually farther from the group than the others, it will look like he doesn't belong.

DEPTH OF FIELD AND SHARPNESS

When working with small groups, I typically work with the lens stopped down to increase the depth of focus I have to work with.

Another difference between single subjects and groups is the resolution at which they must be photographed to achieve the same perceived clarity. Working with a single subject, you can create a beautiful final image using an

8-megapixel camera. A group of ten people requires a camera with a higher resolution to achieve a similar clarity and perceived detail. As the facial size reduces within the frame, less detail can be seen and the high resolution is needed to produce a salable image.

With the smaller facial size also comes the issue of sharpness. I always use a very heavy tripod and a fast shutter speed. Typically, I use a studio flash as my main light and the ambient light as the fill. This does away with any movement in the group, which is especially important when photographing families that include small children. It also helps balance the light to avoid color casts.

MAKE EACH PERSON LOOK GREAT

Ultimately, whether the pose includes one person or a family of twenty-five, the goals are the same: make each person look beautiful, produce an image that meets the requirements needed for the end use, and capture a part of that spark that makes them who they are.

In the final chapter we will discuss some other factors that affect posing, because posing is impacted by every other decision made in the planning process. Having control over your posing really does no good if you have no control over all the *other* factors in the portrait you are creating.

Consistent spacing between the subjects makes the group look cohesive.

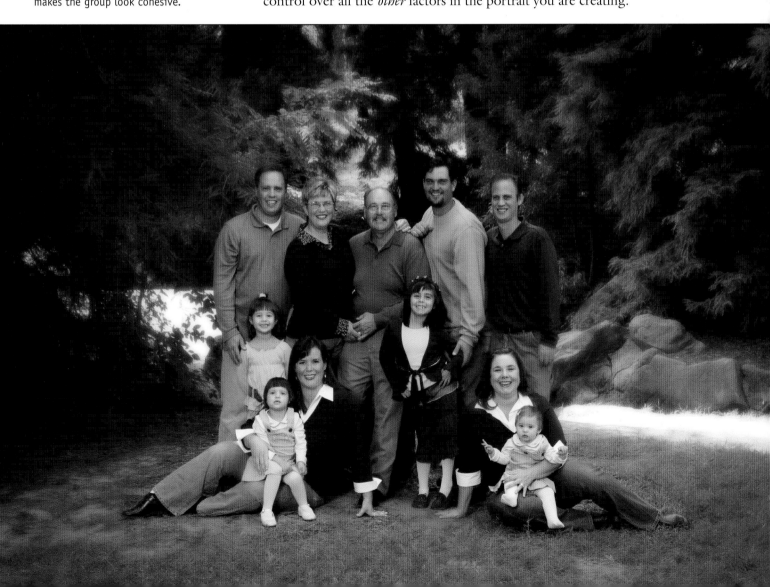

9. Controlling the Session—and Your Business

Ihad planned to finish this book at the end of the previous chapter, but I received an e-mail that made me think that maybe one or two more chapters were needed. In this e-mail, I was reminded that many photographers have a hard time controlling their sessions simply because they have a hard time controlling their businesses.

HOW TROUBLES GET STARTED

In this e-mail, the photographer asked why we don't put prices on our website for senior portraits. I responded that price doesn't matter. She was shocked and told me that price is the most important factor to her clients. She could never leave out the prices from her website. Trying to explain, I told her that most of the time, photographers worry much more about prices than clients do. In this competitive market, very few studios are priced that far above other studios of a similar quality. I feel it is the photographers' overemphasis on pricing that attracts bargain shoppers to *cheap* portraits. After all, people who want *beautiful* portraits don't respond well to businesses that promote themselves as bargain-basement operations.

Just like the woman who sent me this e-mail, many photographers don't realize that it is their lack of business skills and not "problem clients" that makes their work so difficult to deal with. These photographers encounter problems from the point of the first phone call, to the time they make the appointment, through to the session, the order, and finally the order pick-up. As a result, they see their clients as nothing more than troublesome penny pinchers who are out to ruin their lives.

The truth is, photographers often make it hard on clients by not providing them with the proper information and by failing to define their business so the potential clients know what to expect from the studio. You have to look at each step in the average session and make the process as easy for the client as possible—and do everything in your power to accurately define your business so the only calls you get are from clients who actually want what you offer.

They see their clients as troublesome penny pinchers who are out to ruin their lives.

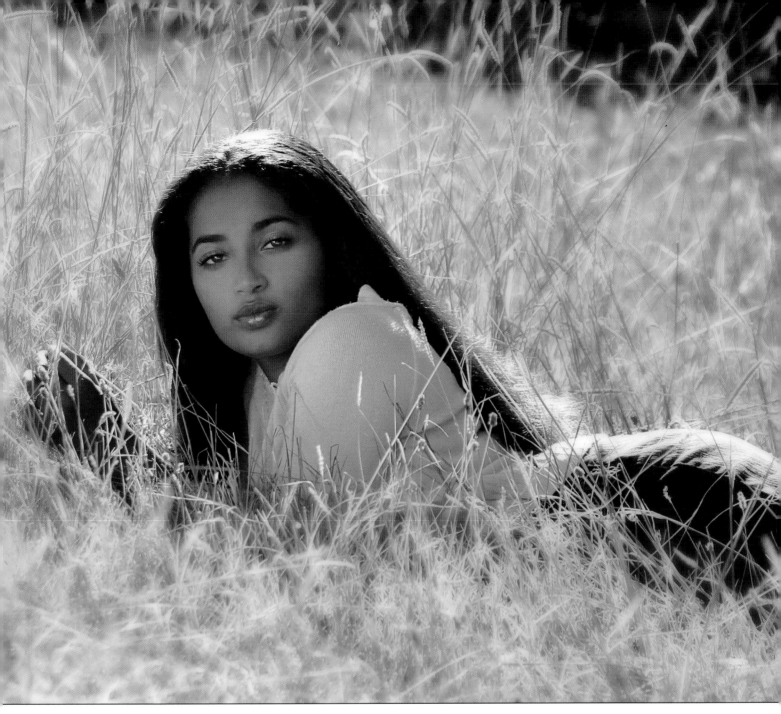

When clients understand your business and know how to prepare for their sessions, the results will make everyone happy.

People call your business because of exposure that you have paid for (advertising) or exposure to the many other parts of your marketing plan (word of mouth, business cards and brochures, portraits on display, etc.). Without advertising and a good marketing plan, the phone doesn't ring. Without a clearly defined style in your advertising and marketing, you get phone calls from clients who aren't a good match for what you do.

Many photographers spend a fortune on the finest mailers and marketing pieces—pieces that visually say, "We are good and probably charge more than other studios." In many cases, however, the location of the studio, the photographer's experience, and the overall business don't live up to that more prestigious feeling. Some photographers do the exact opposite—they have

The images you show at your studio should be shots you can actually re-create for future clients.

cheesy ads and marketing pieces going out to clients, despite the fact that the studio location, photographer's experience, and prices charged are very upscale. In both cases, the phone rings a great deal, but few callers turn into clients.

Another problematic inconsistency occurs when you show work that you cannot re-create for future clients. I can't count the number of photographers I've seen displaying wedding photos taken in exotic locations where their clients hired them to travel. Instead of impressing potential clients, this can lead to uncomfortable discussions with future brides about why you can't provide the same looks for them that you showcased in your display.

Two good examples of this happened to me recently. As I was finishing writing this book, we were getting ready to go on our family vacation to Spain. My son is a senior in high school and wanted to take his senior portraits in Spain. My first thought was how amazing these portraits would be for display—but the businessperson in me realized that for every one person who might spend the $15,000 to photograph their child in Spain, there would be tens, if not hundreds, who would be upset because they couldn't do photographs like the ones that impressed them.

As I was finishing my last book, I contacted the people who run the Alumni House at our local university. Their building is set up as a very large, very upscale home, and when I explained that I was interested in using the

site to create portraits to use in a book, there was no problem with getting the okay. The house, the session, and the senior girl we used all were perfect (at least in the final portraits!). I was so impressed with the images that I wanted to include some of them in our studio displays, mailings, and website. Then, I started thinking as a businessperson. I realized that I would be showing potential clients portraits they could never do. The people running the Alumni House thought it was cool to let us use the house once, but they wouldn't appreciate working around full-day sessions several times a year. Thinking this way is critical to controlling your business and looking like a professional in the eyes of your client.

You don't see McDonald's advertising itself as a great place for a formal anniversary dinner. Neither do you see finer restaurants installing drive-

I realized that I would be showing potential clients portraits they could never do.

LEFT—Because they trust me, my clients are responsive and follow my guidance when it comes to clothing selection and posing. FACING PAGE—Our Dodge Viper and Harley-Davidson motorcycle are popular props for senior portraits.

through windows. These businesses define their market and let those who see their advertising know what to expect. This reduces problems for the client and builds the needed respect for the business.

So . . . what does all this have to do with posing? Well, when my staff informs our clients what they need to do to look their best, or when I explain why a client should wear a certain outfit or do a certain pose, I rarely get any argument. That's because my clients look to me as a professional and trust that I know what I am doing—after all, that's why they came to me for their portraits. If your clients don't listen to your suggestions and advice, it is because there is a lack of respect. That is *your* fault, not theirs!

PREVENTING PROBLEMS

The key to avoiding problems is to create a consistent message. At my studio, we go for an upscale (but not intimidating) feel. The studio itself is located near the most exclusive shopping area in the city. When seniors arrive at the studio, they can select from backgrounds and sets such as a Dodge Viper, a Harley-Davidson motorcycle, and high-quality sets by Scenic Designs and Off The Wall.

They also have an experienced professional photographer (me!) who is the author of nine books and numerous articles—and I always look the part; I

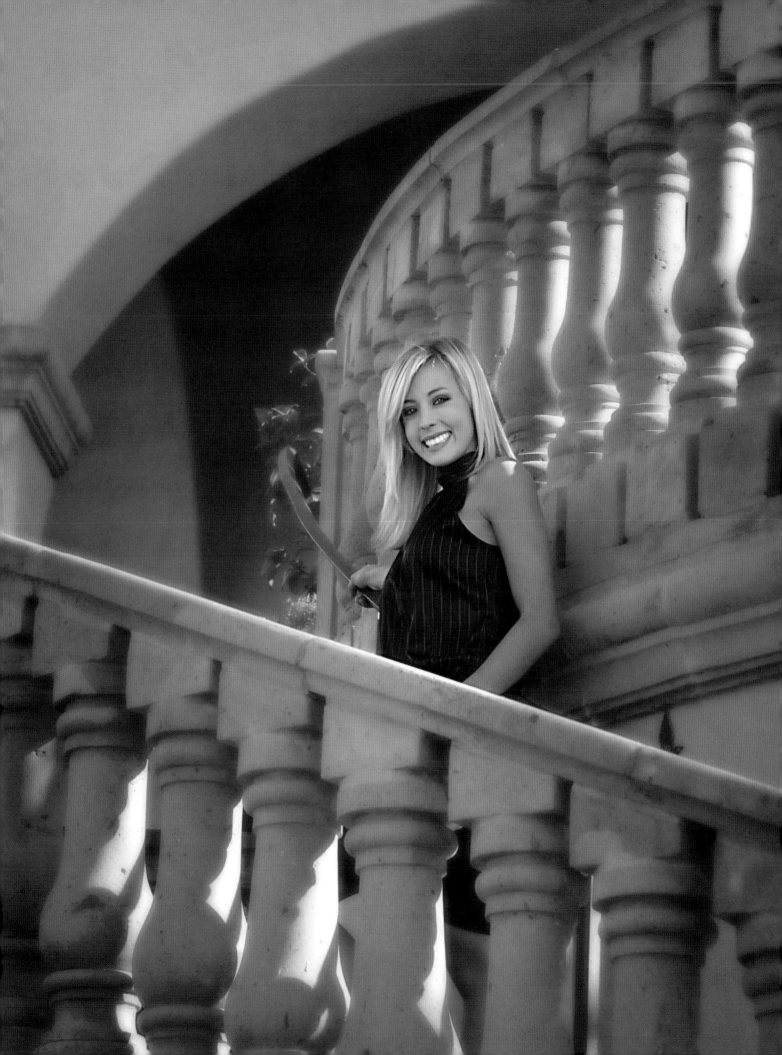

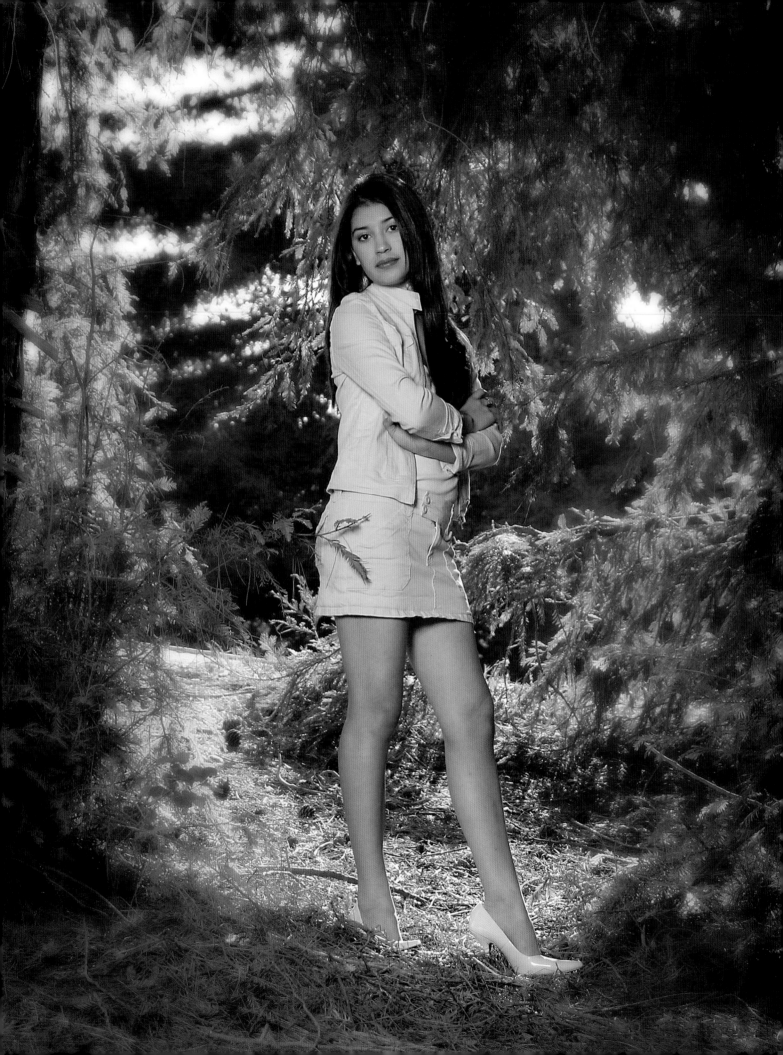

ABOVE AND FACING PAGE—Clients know our work isn't going to be cheap—but it's not so over the top that people are intimidated.

dress in a suit in winter, a shirt and tie in summer, and a nice pair of khakis and a shirt for typical outdoor sessions. Additionally, I speak clearly and respectfully to my clients and my subjects. I know what I'm doing, and it's clear in every facet of how I present myself.

The result of this is that our clients know we are not going to be cheap. Still, our style isn't so over-the-top that it scares off people of average means who want nice senior portraits without breaking the bank. This feeling is echoed in our marketing and in all of our contact with clients. For example, we use humor to bring a more down-to-earth feeling to our company. When a potential client calls, they are greeted by a professional sounding person with a great sense of humor. Ultimately, we are clear about who we are as a business and who they should be if they want to use our service.

And speaking of phone calls, the next important step in preventing problems is educating the client. When our phone person makes each appointment, they explain everything the client needs to do. This includes paying for the session in advance at the time of scheduling and planning to place their order immediately after the session is over. They also discuss how to dress and point the client to our website for additional help on getting ready for their session. Finally, they ask the client to arrive fifteen minutes early for the session so they can select their background ideas.

We follow up by sending them complete information about the process of taking and ordering their portraits. The information emphasizes that the people in the portraits they have seen (presumably the reason they called to book their session) look great because they took the time to prepare correctly for their sessions. We use a simple scenario to explain, on the other hand, how a bad choice of clothing can ruin an otherwise beautiful portrait. This shows a young lady in a shirt or sweater that is too fitted and demonstrates some of

the problems this creates—and how much these types of corrections usually cost the client. This is also a good time to discuss solids as opposed to patterns; while the type of correction shown in the tight-shirt example is costly with a solid-colored shirt, with an intricate pattern it might not even be possible. Once we have explained not only what they should do but why they should do it (and what can happen if they don't), people generally follow our advice. (*Note:* Some photographers handle this in a personal consultation, but this is very time consuming. I only offer personal consultations for a select few clients and when the order is expected to exceed $2000.)

The information we give to our clients before their session also covers all the appropriate accessories, preparation (nails, hair, shaving/waxing, tanning, etc.), as well as suggestions about makeup. Unlike some senior studios, we don't offer a makeup artist. Like photographers, makeup artists each have a

Once we have explained what

they should do and why,

people generally follow our advice.

unique style that is visible when you look at their work. No matter how the makeup artist does it, the makeup they create will be different than the way the woman does her own makeup. In a portrait that is going to sell to family members (not a glamour-shot style), however, you want the person to appear as they see themselves and as others see them everyday. Therefore, we tell our clients to wear their makeup the same way they would for a special evening out. With just that advice, we rarely have a problem with a young lady not liking her appearance because of their makeup. (*Note:* The only time we venture into professional makeup is when we have a girl who never wears makeup. Then, we have an artist apply basic foundation, mascara, and some

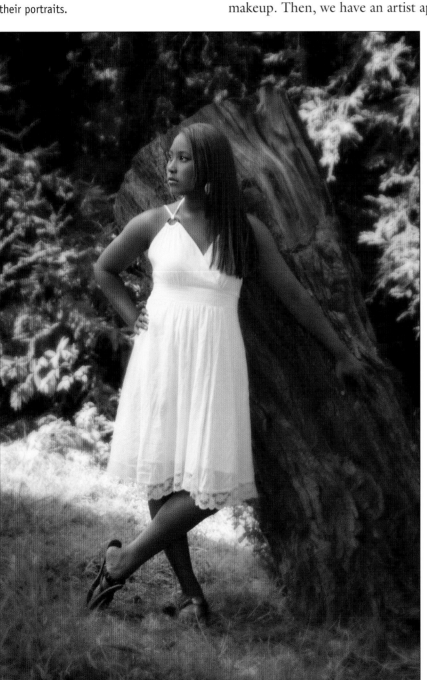

We tell our clients to wear their makeup the same way they would for a special evening out. If they apply it themselves, we rarely have a problem with them not liking it in their portraits.

tinted lip gloss. This doesn't make her look like someone else, it just calls a bit of attention to her eyes and adds a little color to her face with the lip gloss.)

As you can see, throughout the entire process we address the same questions and concerns that every studio in the country has to deal with, but with a difference: I am not afraid. In fact, I *want* to send some business away. We are not a studio for everyone. If we were, I would have set up shop in a mall. There are many potential clients who don't have the money to pay my prices, even though we are competitive with other quality senior studios. Other seniors and their parents don't care about taking creative senior portraits; they just want the same headshot seniors have been getting for decades. For these clients, our studio is not a good match, and that's fine. It lets us keep our focus on those clients whose tastes and goals suit our own.

THE LONG AND SHORT OF IT

Until you take control of your business, you will never take control of your sessions or subjects. You'll tell them what to do, they'll ignore you—and, then, when things go badly because of their choices, they will blame you.

When it comes to clients, the root of virtually every problem is a lack of communication. You didn't know something about your client, or they didn't know something about you. Every time we have a "problem" client, we get together and discuss the missing information that caused the problem. I can honestly say that ninety percent of the time it is information *we* neglected to provide to the client that created the problem. Even if the problem is rooted in a lack of information from the client, though, it's still *your* fault; you never took the time to ask what they wanted.

It shouldn't be hard to be your client. If it is, you won't have many clients—and the ones you do have won't respect you. If you make it easy to work with you, your problems with clients will be reduced. You will work with clients who want to work with you and who truly understand why you are the best studio for them.

When it comes to clients, the root of virtually every problem is a lack of communication.

Here, the subject's white top is in a light area of the background, while her jeans are in a darker area. Taking this kind of care is what's required to create professional-quality portraits.

I wanted to finish this book by taking you through a session from start to finish. Often, I look at photographer's display images and am impressed by the quality of the work. Then, I will a have client bring in their proofs from that same studio and wonder what happened. Did the janitor shoot the session? Or does the photographer subscribe to the theory that if you shoot enough arrows, sooner or later you will hit the target? To my thinking, being a professional photographer isn't about creating a single perfect image in a session, it is about making the client's job choosing images almost impossible because each pose and each scene is so good that they want them all. Here's how I go about achieving that goal.

1. QUALIFY AND PREPARE THE CLIENT

As we have already discussed, before I work with a client, I know that they want to be photographed by our studio. The staff has talked with them about the type of session they want, and they have been given detailed guidelines on how (and how not) to dress.

2. CHOOSE THE SCENES

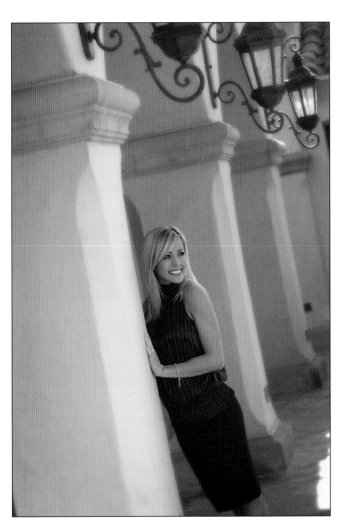

Before the client arrives, I choose the scenes for the session.

Before the client arrives, I select my favorite five scenes at the location where we will be working. This is the standard number of scene changes included in our outdoor sessions. I also work out the lighting needed to photograph a subject in these scenes, so we will be ready to move quickly from one spot to the next.

3. EVALUATE THE CLIENT AND CLOTHING

To start the session, I look over the clothing the client has brought with her to the session. I also look for flaws or problems that will need to be addressed

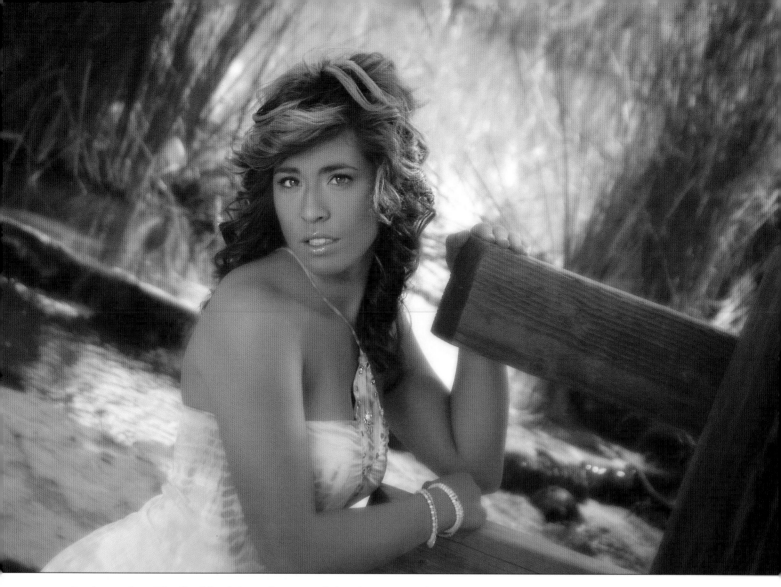

in the posing. Finally, I look into the eyes of the client to see how well they reflect light, which is especially important outdoors.

4. PLAN THE CLOTHING CHANGES

If we will be doing full-length shots, I determine which outfits will look best (and check for matching shoes). I also look for which outfits will be best for the head-and-shoulders poses. I then write down the order of the clothing changes based on where each outfit will look best. That way, no time is wasted going back and forth from scene to scene or having the client change back into an outfit they have already worn. We allow each client to change twice to avoid wasting too much time (and I typically work with two clients at a time, so I'm photographing one client while the other client is changing).

5. DISCUSS THE STRATEGY

Once the client has changed into to her first outfit and the lighting and camera position are set up, I take a few minutes to talk about how I will photograph her. Here's what I say—word for word.

One of the positive comments we always get from our clients is that our images make people look relaxed and natural.

Before we get started, there are few things that I will explain. First off, I will do each pose for you and then I will help you into the pose. I will make sure you look perfect in every way. The hardest part of the whole thing is your expression, because that's the one thing I can't fix for you. Guys worry about smiling at all, girls and their mothers want "the perfect smile" or "their smile." The average person smiles 150 times a day, and when you smile like that, it's perfect—because you are not thinking about it, you are simply reacting to what someone has said or done. That's what I want you to do. I would much rather you burst out laughing and let me take the portrait when it looks good, rather than worry about whether your smile is too big or too small. So if you relax and don't think about it, you will look beautiful.

The next thing is about the posing. I have designed poses that make a person look their best. For women, beauty isn't just about the face, it's also looking as thin as possible. There isn't a woman alive who wants her hips and thighs to look any larger than they really are or to see the waistband of her jeans start to cut into her waistline as she sits down. So, these poses aren't always *comfortable*, but they will hide or soften these problem areas and make you look your best.

One of the positive comments we always get from our clients is that our images make people look relaxed and natural—and how relaxed the people in the session felt while I was photographing them. In order for me to accomplish this, they have to understand why I pose them the way I do. I want the client to know I will take care of everything, fix any problems, and both show and explain everything I want them to do.

For women, beauty isn't just about the face, it's also looking as thin as possible.

Conclusion

My business has been built on the basis of creating portraits that make the client look their best and have lasting appeal because they make sense visually. When you make posing decisions based on these two factors, you start creating portraits that please your clients and sell well. It also means you can create a good living for you and your family.

In closing, I hope that you have not only increased the number of poses that you can offer your clients, but that you also have a better understanding of when to use them to create portraits that have a sense of style. The photographers who pose people the best are those who truly empathize with their clients, trying to deal with their shortcomings and making the best of their bad decisions.

Index

GARAGE GLAMOUR™
DIGITAL NUDE AND BEAUTY PHOTOGRAPHY MADE SIMPLE

Rolando Gomez

Glamour photography is more popular than ever. This book will show you how to produce sultry, creative glamour images with a minimum of equipment. $34.95 list, 8.5x11, 128p, 150 color photos, index, order no. 1820.

PROFESSIONAL PORTRAIT LIGHTING
TECHNIQUES AND IMAGES FROM MASTER PHOTOGRAPHERS

Michelle Perkins

Get a behind-the-scenes look at the lighting techniques employed by the world's top portrait photographers. $34.95 list, 8.5x11, 128p, 200 color photos, index, order no. 2000.

MASTER POSING GUIDE
FOR CHILDREN'S PORTRAIT PHOTOGRAPHY

Norman Phillips

Create perfect portraits of infants, tots, kids, and teens. Includes techniques for standing, sitting, and floor poses for boys and girls, individuals, and groups. $34.95 list, 8.5x11, 128p, 305 color images, order no. 1826.

MASTER'S GUIDE TO WEDDING PHOTOGRAPHY
CAPTURING UNFORGETTABLE MOMENTS AND LASTING IMPRESSIONS

Marcus Bell

Learn to capture the unique energy and mood of each wedding and build a lifelong client relationship. $34.95 list, 8.5x11, 128p, 200 color photos, index, order no. 1832.

MASTER LIGHTING GUIDE
FOR COMMERCIAL PHOTOGRAPHERS

Robert Morrissey

Use the tools and techniques pros rely on to land corporate clients. Includes diagrams, images, and techniques for a failsafe approach for shots that sell. $34.95 list, 8.5x11, 128p, 110 color photos, 125 diagrams, index, order no. 1833.

MASTER GUIDE FOR GLAMOUR PHOTOGRAPHY

Chris Nelson

Establish a rapport with your model, ensure a successful shoot, and master the essential digital fixes your clients demand. Includes lingerie, semi-nude, and nude images. $34.95 list, 8.5x11, 128p, 200 color photos, index, order no. 1836.

SOFTBOX LIGHTING TECHNIQUES
FOR PROFESSIONAL PHOTOGRAPHERS

Stephen A. Dantzig

Learn to use one of photography's most popular lighting devices to produce soft and flawless effects for portraits, product shots, and more. $34.95 list, 8.5x11, 128p, 260 color images, index, order no. 1839.

CHILDREN'S PORTRAIT PHOTOGRAPHY HANDBOOK

Bill Hurter

Packed with inside tips from industry leaders, this book shows you the ins and outs of working with some of photography's most challenging subjects. $34.95 list, 8.5x11, 128p, 175 color images, index, order no. 1840.

ROLANDO GOMEZ'S GLAMOUR PHOTOGRAPHY
PROFESSIONAL TECHNIQUES AND IMAGES

Learn how to create classy glamour portraits your clients will adore. Rolando Gomez takes you behind the scenes, offering invaluable technical and professional insights. $34.95 list, 8.5x11, 128p, 150 color images, index, order no. 1842.

PROFESSIONAL PORTRAIT POSING
TECHNIQUES AND IMAGES FROM MASTER PHOTOGRAPHERS

Michelle Perkins

Learn how master photographers pose subjects to create unforgettable images. $34.95 list, 8.5x11, 128p, 175 color images, index, order no. 2002.

DIGITAL PHOTOGRAPHY FOR CHILDREN'S AND FAMILY PORTRAITURE, 2nd Ed.

Kathleen Hawkins

Learn how staying on top of advances in digital photography can boost your sales and improve your artistry and workflow. $34.95 list, 8.5x11, 128p, 195 color images, index, order no. 1847.

MASTER LIGHTING GUIDE
FOR WEDDING PHOTOGRAPHERS

Bill Hurter

Capture perfect lighting quickly and easily at the ceremony and reception—indoors and out. Includes tips from the pros for lighting individuals, couples, and groups. $34.95 list, 8.5x11, 128p, 200 color photos, index, order no. 1852.

POSING TECHNIQUES FOR PHOTOGRAPHING MODEL PORTFOLIOS

Billy Pegram

Learn to evaluate your model and create flattering poses for fashion photos, catalog and editorial images, and more. $34.95 list, 8.5x11, 128p, 200 color images, index, order no. 1848.

THE ART OF PREGNANCY PHOTOGRAPHY

Jennifer George

Learn the essential posing, lighting, composition, business, and marketing skills you need to create stunning pregnancy portraits your clientele can't do without! $34.95 list, 8.5x11, 128p, 150 color photos, index, order no. 1855.

BIG BUCKS SELLING YOUR PHOTOGRAPHY, 4th Ed.

Cliff Hollenbeck

Build a new business or revitalize an existing one with the comprehensive tips in this popular book. Includes twenty forms you can use for invoicing clients, collections, follow-ups, and more. $34.95 list, 8.5x11, 144p, resources, business forms, order no. 1856.

ILLUSTRATED DICTIONARY OF PHOTOGRAPHY

Barbara A. Lynch-Johnt & Michelle Perkins

Gain insight into camera and lighting equipment, accessories, technological advances, film and historic processes, famous photographers, artistic movements, and more with the concise descriptions in this illustrated book. $34.95 list, 8.5x11, 144p, 150 color images, order no. 1857.

PROFESSIONAL PORTRAIT PHOTOGRAPHY
TECHNIQUES AND IMAGES FROM MASTER PHOTOGRAPHERS

Lou Jacobs Jr.

Veteran author and photographer Lou Jacobs Jr. interviews ten top portrait pros, sharing their secrets for success. $34.95 list, 8.5x11, 128p, 150 color photos, index, order no. 2003.

EXISTING LIGHT
TECHNIQUES FOR WEDDING AND PORTRAIT PHOTOGRAPHY

Bill Hurter

Learn to work with window light, make the most of outdoor light, and use fluorescent and incandescent light to best effect. $34.95 list, 8.5x11, 128p, 150 color photos, index, order no. 1858.

THE SANDY PUC' GUIDE TO
CHILDREN'S PORTRAIT PHOTOGRAPHY

Learn how Puc' handles every client interaction and session for priceless portraits, the ultimate client experience, and maximum profits. $34.95 list, 8.5x11, 128p, 180 color images, index, order no. 1859.

MINIMALIST LIGHTING
PROFESSIONAL TECHNIQUES FOR LOCATION PHOTOGRAPHY

Kirk Tuck

Use small, computerized, battery-operated flash units and lightweight accessories to get the top-quality results you want on location! $34.95 list, 8.5x11, 128p, 175 color images and diagrams, index, order no. 1860.

THE KATHLEEN HAWKINS GUIDE TO
SALES AND MARKETING FOR PROFESSIONAL PHOTOGRAPHERS

Create a brand identity that lures clients to your studio, then wows them with great customer service and powerful images that will ensure big sales and repeat clients. $34.95 list, 8.5x11, 128p, 175 color images, index, order no. 1862.

SIMPLE LIGHTING TECHNIQUES
FOR PORTRAIT PHOTOGRAPHERS

Bill Hurter

Make complicated lighting setups a thing of the past. In this book, you'll learn how to streamline your lighting for more efficient shoots and more natural-looking portraits. $34.95 list, 8.5x11, 128p, 175 color images, index, order no. 1864.

SCULPTING WITH LIGHT

Allison Earnest

Learn how to design the lighting effect that will best flatter your subject. Studio and location lighting setups are covered in detail with an assortment of helpful variations provided for each shot. $34.95 list, 8.5x11, 128p, 175 color images, diagrams, index, order no. 1867.

STEP-BY-STEP WEDDING PHOTOGRAPHY

Damon Tucci

Deliver the the top-quality images your clients demand with the tips in this essential book. Tucci shows you how to become more creative, more efficient, and more successful. $34.95 list, 8.5x11, 128p, 175 color images, index, order no. 1868.

ROLANDO GOMEZ'S
POSING TECHNIQUES FOR GLAMOUR PHOTOGRAPHY

Learn everything you need to pose a subject—from head to toe. Gomez covers each area of the body in detail, showing you how to address common problems and create a flattering look. $34.95 list, 8.5x11, 128p, 110 color images, index, order no. 1869.

PROFESSIONAL WEDDING PHOTOGRAPHY

Lou Jacobs Jr.

Jacobs explores techniques and images from over a dozen top professional wedding photographers in this revealing book, taking you behind the scenes and into the minds of the masters. $34.95 list, 8.5x11, 128p, 175 color images, index, order no. 2004.

THE ART OF CHILDREN'S PORTRAIT PHOTOGRAPHY

Tamara Lackey

Learn how to create images that are focused on emotion, relationships, and storytelling. Lackey shows you how to engage children, conduct fun and efficient sessions, and deliver images that parents will cherish. $34.95 list, 8.5x11, 128p, 240 color images, index, order no. 1870.

50 LIGHTING SETUPS FOR PORTRAIT PHOTOGRAPHERS

Steven H. Begleiter

Filled with unique portraits and lighting diagrams, plus the "recipe" for creating each one, this book is an indispensible resource you'll rely on for a wide range of portrait situations and subjects. $34.95 list, 8.5x11, 128p, 150 color images and diagrams, index, order no. 1872.

DIGITAL PHOTOGRAPHY BOOT CAMP, 2nd Ed.

Kevin Kubota

This popular book based on Kevin Kubota's sell-out workshop series is now fully updated with techniques for Adobe Photoshop and Lightroom. It's a down-and-dirty, step-by-step course for professionals! $34.95 list, 8.5x11, 128p, 220 color images, index, order no. 1873.

100 TECHNIQUES FOR PROFESSIONAL WEDDING PHOTOGRAPHERS

Bill Hurter

Top photographers provide tips for becoming a better shooter—from optimizing your gear, to capturing perfect moments, to streamlining your workflow. $34.95 list, 8.5x11, 128p, 180 color images and diagrams, index, order no. 1875.

DOUG BOX'S
GUIDE TO POSING
FOR PORTRAIT PHOTOGRAPHERS

Based on Doug Box's popular workshops for professional photographers, this visually intensive book allows you to quickly master the skills needed to pose men, women, children, and groups. $34.95 list, 8.5x11, 128p, 200 color images, index, order no. 1878.

500 POSES FOR PHOTOGRAPHING WOMEN

Michelle Perkins

A vast assortment of inspiring images, from head-and-shoulders to full-length shots, and classic to contemporary styles—perfect for when you need a little shot of inspiration to create a new pose. $34.95 list, 8.5x11, 128p, 500 color images, index, order no. 1879.

POWER MARKETING, SELLING, AND PRICING
A BUSINESS GUIDE FOR WEDDING AND PORTRAIT PHOTOGRAPHERS, 2ND ED.

Mitche Graf

Master the skills you need to take control of your business, boost your bottom line, and build the life you want. $34.95 list, 8.5x11, 144p, 90 color images, index, order no. 1876.